Dear Claire / Barley

here's to our future and

I will always love you for

eternity......

LFECB xxxxxx

Kevin

Francis Frith's
Marlborough

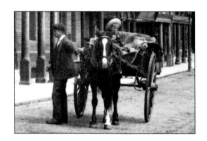

Photographic Memories

Francis Frith's
Marlborough

Dorothy Treasure

FRITH
BOOK Co

First published in the United Kingdom in 2001 by
Frith Book Company Ltd

Paperback Edition 2001
ISBN 1-85937-336-4

British Library Cataloguing in Publication Data

Francis Frith's Marlborough
Dorothy Treasure

Frith Book Company Ltd
Frith's Barn, Teffont,
Salisbury, Wiltshire SP3 5QP
Tel: +44 (0) 1722 716 376
Email: info@francisfrith.co.uk
www.francisfrith.co.uk

Printed and bound in Great Britain

Front Cover: Town Hall 1902 48637

Contents

Francis Frith: *Victorian Pioneer*

FRANCIS FRITH, Victorian founder of the world-famous photographic archive, was a complex and multi-talented man. A devout Quaker and a highly successful Victorian businessman, he was both philosophic by nature and pioneering in outlook.

By 1855 Francis Frith had already established a wholesale grocery business in Liverpool, and sold it for the astonishing sum of £200,000, which is the equivalent today of over £15,000,000. Now a multi-millionaire, he was able to indulge his passion for travel. As a child he had pored over travel books written by early explorers, and his fancy and imagination had been stirred by family holidays to the sublime mountain regions of Wales and Scotland. 'What a land of spirit-stirring and enriching scenes and places!' he had written. He was to return to these scenes of grandeur in later years to 'recapture the thousands of vivid and tender memories', but with a different purpose. Now in his thirties, and captivated by the new science of photography, Frith set out on a series of pioneering journeys to the Nile regions that occupied him from 1856 until 1860.

Intrigue and Adventure

He took with him on his travels a specially-designed wicker carriage that acted as both dark-room and sleeping chamber. These far-flung journeys were packed with intrigue and adventure. In his life story, written when he was sixty-three, Frith tells of being held captive by bandits, and of fighting 'an awful midnight battle to the very point of surrender with a deadly pack of hungry, wild dogs'. Sporting flowing Arab costume, Frith arrived at Akaba by camel seventy years before Lawrence, where he encountered 'desert princes and rival sheikhs, blazing with jewel-hilted swords'.

During these extraordinary adventures he was assiduously exploring the desert regions bordering the Nile and patiently recording the antiquities and peoples with his camera. He was the first photographer to venture beyond the sixth cataract. Africa was still the mysterious 'Dark Continent', and Stanley and Livingstone's historic meeting was a decade into the future. The conditions for picture taking confound belief. He laboured for hours in his wicker dark-room in the sweltering heat of the desert, while the volatile chemicals fizzed dangerously in their trays. Often he was forced to work in remote tombs and caves where conditions were cooler. Back in London he exhibited his photographs and was 'rapturously cheered' by members of the Royal Society. His reputation as a

photographer was made overnight. An eminent modern historian has likened their impact on the population of the time to that on our own generation of the first photographs taken on the surface of the moon.

Venture of a Life-Time

Characteristically, Frith quickly spotted the opportunity to create a new business as a specialist publisher of photographs. He lived in an era of immense and sometimes violent change. For the poor in the early part of Victoria's reign work was a drudge and the hours long, and people had precious little free time to enjoy themselves. Most had no transport other than a cart or gig at their disposal, and had not travelled far beyond the boundaries of their own town or village. However,

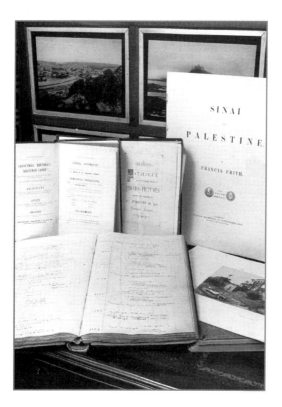

by the 1870s, the railways had threaded their way across the country, and Bank Holidays and half-day Saturdays had been made obligatory by Act of Parliament. All of a sudden the ordinary working man and his family were able to enjoy days out and see a little more of the world.

With characteristic business acumen, Francis Frith foresaw that these new tourists would enjoy having souvenirs to commemorate their days out. In 1860 he married Mary Ann Rosling and set out with the intention of photographing every city, town and village in Britain. For the next thirty years he travelled the country by train and by pony and trap, producing fine photographs of seaside resorts and beauty spots that were keenly bought by millions of Victorians. These prints were painstakingly pasted into family albums and pored over during the dark nights of winter, rekindling precious memories of summer excursions.

The Rise of Frith & Co

Frith's studio was soon supplying retail shops all over the country. To meet the demand he gathered about him a small team of photographers, and published the work of independent artist-photographers of the calibre of Roger Fenton and Francis Bedford. In order to gain some understanding of the scale of Frith's business one only has to look at the catalogue issued by Frith & Co in 1886: it runs to some 670 pages, listing not only many thousands of views of the British Isles but also many photographs of most European countries, and China, Japan, the USA and Canada – note the sample page shown above from the hand-written *Frith & Co* ledgers detailing pictures taken. By 1890 Frith had created the greatest specialist photographic publishing company in the world,

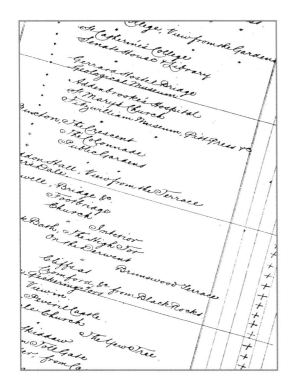

with over 2,000 outlets – more than the combined number that Boots and W H Smith have today! The picture on the right shows the *Frith & Co* display board at Ingleton in the Yorkshire Dales. Beautifully constructed with mahogany frame and gilt inserts, it could display up to a dozen local scenes.

Postcard Bonanza

The ever-popular holiday postcard we know today took many years to develop. In 1870 the Post Office issued the first plain cards, with a pre-printed stamp on one face. In 1894 they allowed other publishers' cards to be sent through the mail with an attached adhesive halfpenny stamp. Demand grew rapidly, and in 1895 a new size of postcard was permitted called the court card, but there was little room for illustration. In 1899, a year after

Frith's death, a new card measuring 5.5 x 3.5 inches became the standard format, but it was not until 1902 that the divided back came into being, with address and message on one face and a full-size illustration on the other. *Frith & Co* were in the vanguard of postcard development, and Frith's sons Eustace and Cyril continued their father's monumental task, expanding the number of views offered to the public and recording more and more places in Britain, as the coasts and countryside were opened up to mass travel.

Francis Frith died in 1898 at his villa in Cannes, his great project still growing. The archive he created continued in business for another seventy years. By 1970 it contained over a third of a million pictures of 7,000 cities, towns and villages. The massive photographic record Frith has left to us stands as a living monument to a special and very remarkable man.

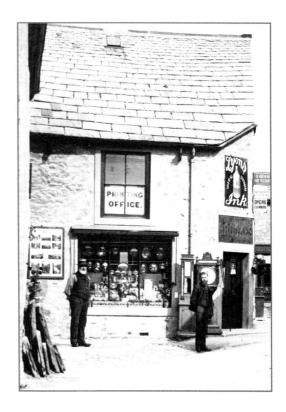

Frith's Archive: *A Unique Legacy*

FRANCIS FRITH'S legacy to us today is of immense significance and value, for the magnificent archive of evocative photographs he created provides a unique record of change in 7,000 cities, towns and villages throughout Britain over a century and more. Frith and his fellow studio photographers revisited locations many times down the years to update their views, compiling for us an enthralling and colourful pageant of British life and character.

We tend to think of Frith's sepia views of Britain as nostalgic, for most of us use them to conjure up memories of places in our own lives with which we have family associations. It often makes us forget that to Francis Frith they were records of daily life as it was actually being lived in the cities, towns and villages of his day. The Victorian age was one of great and often bewildering change for ordinary people, and though the pictures evoke an impression of slower times, life was as busy and hectic as it is today.

We are fortunate that Frith was a photographer of the people, dedicated to recording the minutiae of everyday life. For it is this sheer wealth of visual data, the painstaking chronicle of changes in dress, transport, street layouts, buildings, housing, engineering and landscape that captivates us so much today. His remarkable images offer us a powerful link with the past and with the lives of our ancestors.

Today's Technology

Computers have now made it possible for Frith's many thousands of images to be accessed almost instantly. In the Frith archive today, each photograph is carefully 'digitised' then stored on a CD Rom. Frith archivists can locate a single photograph amongst thousands within seconds. Views can be catalogued and sorted under a variety of categories of place and content to the immediate benefit of researchers.

Inexpensive reference prints can be created for them at the touch of a mouse button, and a wide range of books and other printed materials assembled and published for a wider, more general readership - in the next twelve months over a hundred Frith local history titles will be published! The day-to-day workings of the archive are very different from how they were in Francis Frith's time: imagine the herculean task of sorting through eleven tons of glass negatives as Frith had to do to locate a particular sequence of pictures! Yet

See Frith at www.francisfrith.co.uk

the archive still prides itself on maintaining the same high standards of excellence laid down by Francis Frith, including the painstaking cataloguing and indexing of every view.

It is curious to reflect on how the internet now allows researchers in America and elsewhere greater instant access to the archive than Frith himself ever enjoyed. Many thousands of individual views can be called up on screen within seconds on one of the Frith internet sites, enabling people living continents away to revisit the streets of their ancestral home town, or view places in Britain where they have enjoyed holidays. Many overseas researchers welcome the chance to view special theme selections, such as transport, sports, costume and ancient monuments.

We are certain that Francis Frith would have heartily approved of these modern developments in imaging techniques, for he himself was always working at the very limits of Victorian photographic technology.

The Value of the Archive Today

Because of the benefits brought by the computer, Frith's images are increasingly studied by social historians, by researchers into genealogy and ancestory, by architects, town planners, and by teachers and schoolchildren involved in local history projects.

In addition, the archive offers every one of us an opportunity to examine the places where we and our families have lived and worked down the years. Highly successful in Frith's own era, the archive is now, a century and more on, entering a new phase of popularity.

The Past in Tune with the Future

Historians consider the Francis Frith Collection to be of prime national importance. It is the only archive of its kind remaining in private ownership and has been valued at a million pounds. However, this figure is now rapidly increasing as digital technology enables more and more people around the world to enjoy its benefits.

Francis Frith's archive is now housed in an historic timber barn in the beautiful village of Teffont in Wiltshire. Its founder would not recognize the archive office as it is today. In place of the many thousands of dusty boxes containing glass plate negatives and an all-pervading odour of photographic chemicals, there are now ranks of computer screens. He would be amazed to watch his images travelling round the world at unimaginable speeds through network and internet lines.

The archive's future is both bright and exciting. Francis Frith, with his unshakeable belief in making photographs available to the greatest number of people, would undoubtedly approve of what is being done today with his lifetime's work. His photographs, depicting our shared past, are now bringing pleasure and enlightenment to millions around the world a century and more after his death.

Marlborough - *An Introduction*

Collecting photographs is a time-honoured tradition, keeping alive memories of faces and places for posterity. In coming to Marlborough and its scenic district, Francis Frith is now bringing to light unique images, some of which have not been witnessed for decades. This collection of photographs covers familiar places in Marlborough and at least one or two of every parish around it, including important archaeological sites. Some villages may have been visited perhaps only once, but Frith's photographers returned time after time to Marlborough. They documented not only the established sights, but also brand new buildings, such as the new Catholic Church in George Lane, and the crisp-looking Marlborough Grammar School. In this, Frith displayed great foresight in anticipating the growing interest in local history.

The borough of Marlborough was founded on a royal estate, which stretched from the Kennet to the downlands in the south. By the 11th century, it was known by its present name of Marlborough, meaning 'the barrow of Maerla'. The oldest man-made construction in the town is the tumulus in the grounds of Marlborough College. This mysterious

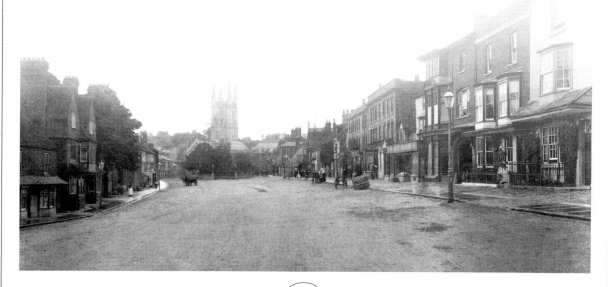

mound has never been adequately explored, and may in future prove to be Maerla's barrow. A wild legend in the 13th century stated that Merlin the magician was buried there; the story persisted through the motto on the Borough Arms, which reads 'where now are the bones of wise Merlin'. A view of the mound may be obtained by standing on the Town Hall steps, or failing that, from Granham Hill which overlooks it from the south.

Until the 16th century, the mound and the castle built there in c1100 were part of Preshute. This is now a parish without a recognisable village, but it once surrounded Marlborough entirely. Marlborough Castle was a royal possession until 1273. William the Conqueror used it as a base when hunting deer in Savernake Forest nearby, Henry I spent Easter there in 1110, and King John was married there. After the Wars of the Roses it fell into ruin and became a possession of the Seymour family, later the Earls of Hertford.

The main settlement in Roman times was Cunetio, now a part of Mildenhall near the river Kennet, but evidence of Anglo-Saxon occupation was found on what is now The Green. St Mary's Church served the needs of the settlement, but at the same time a separate village was forming around the foot of the Conqueror's castle, also with its own parish church of St Peter. The two communities were integrated over time. Marlborough achieved borough status in 1204, which meant it was largely self-governing; it was granted privileges, such as the right to hold a borough court and especially to hold what became prosperous markets twice a week. The spectacularly long and wide High Street running parallel to the river Kennet was probably a result of linking the two settlements, and had been set out by 1086. It was eminently suited for market days.

By the 17th century, Marlborough had six documented town crosses, which would have sheltered traders and their goods. Today, not even one survives. Although Marlborough had its troubles in the Civil War when the town was taken by Royalists in 1642 (a record of this troubled time can be seen in pistol ball and cannon shots on the church towers), it was nothing to what would befall it in 1653. On 28 April that year a fire broke out in the house of Francis Freeman at the west end of the High Street when oak bark used in the tanning of leather caught alight. The fire spread quickly to the properties on both sides of the High Street, most of which had thatch roofs. By the time several hours had elapsed, it is said that around 150 buildings had been destroyed as far as Kingsbury Street, Oxford Street and The Green.

Pevsner's 'Guide to the Buildings of England' stated as late as 1963 that 'no notable domestic architecture exists of before the late 17th century. Nearly all that matters is Georgian'. The destruction was said to have been total, but archaeological

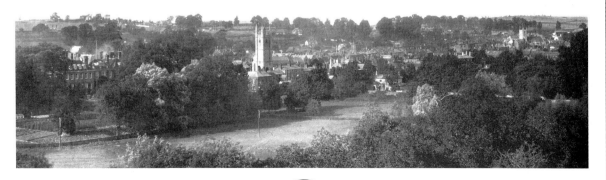

investigation in recent times has determined that some buildings thought to have been totally rebuilt were actually salvaged and repaired. Two probable 15th-century houses have been identified at 75 and 76 High Street, hidden behind 18th- and 19th-century fronts, and 99 High Street, a good 15th-century timber-framed house (now a shop), was possibly a chantry and also escaped the fire. Several other fires occurred in 1679, and another fire in 1690 was so serious that thatch was outlawed in the town (the thatch we now see in Marlborough was once outside the borough boundary).

Marlborough's position on a major east-west route, and other considerations too, determined its commercial success. It had its own mint in 1086, and later a merchant guild. Money-lending may well have been carried out in Silverless Street in the 13th century, which accounts for its curious name. Several Jewish families were known to have been evicted in 1281, and their property was given to good Christians! Marlborough was a major trade centre for goods coming from Bristol and Southampton, such as wine, garlic, grindstones and fish. Marlborough was well watered with rivers, giving rise to a thriving cloth and tanning industry.

A new visitor to the town today may be un-familiar with the landscape, but will recognise the ubiquitous chain stores which have replaced many of the more traditional shops. The Parade, once a semi-industrial area with a rope works and a commercial traveller's inn, is now a bistro, galleries and fashionable shops catering for a far more mobile and leisured population.

Hidden from the town, but with entrances only a short distance from St Peter's Church, is Marlborough College, founded in 1845. The core of the college was C house, formerly the seat of Francis, Lord Seymour, who built it in the early 18th century. He must have cleared away the remains of the former royal castle, which were still quietly decaying in the early 17th century. In 1751 the mansion became a prestigious coaching inn named after the castle. Its reputation was legendary on the London to Bath road, with forty coaches changing horses there daily. As with so many towns, the inn suffered with the coming of the railway and trade declined, so it was fortuitous that the Reverend Charles Plater was at that time searching for suitable premises in which to start his school for the sons of impoverished clergymen.

The original intake was two hundred boys and staff, of which one third were the sons of laymen, who paid extra, but within five years it had become so popular that it was second only in size to Eton. Despite its success, the college was soon in financial difficulty: it did not have the endowments which supported other established schools such as Eton and Harrow. To add to this, discipline had become a problem. 1851 was the year of the 'Great Rebellion,' when there was a constant war between pupils and

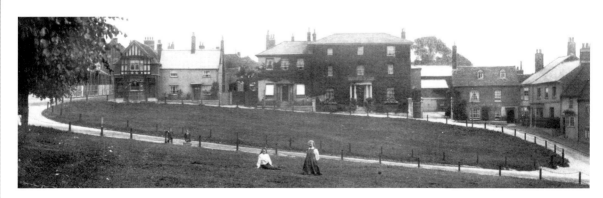

staff. Dr Cotton of Rugby was appointed as new master, and through his great personal strength and charisma he restored the college to its former reputation. Dr G G Bradley succeeded him in 1858. He was responsible for greatly increasing the size of the college by adding many of the out-boarding houses that are familiar to travellers on the Bath Road. He introduced organised sport, such as cricket and rugby, in addition to the ancient game of fives which was already established there. It was in Frank Fletcher's time that the familiar landmark in Marlborough - the archway connecting Field House with the listed North Block over the Bath Road - was completed in 1911. In 1968, the first girls were admitted to the college, whose numbers have steadily risen.

In an age of tourism, Marlborough has been described as the gateway to ancient Wessex. A few short miles to the west lies the Stonehenge and Avebury World Heritage Site, including Avebury Stone Circle, Silbury Hill, West Kennet Long Barrow, Lockeridge Dene and the Devil's Den at Fyfield. All these prehistoric features have the Marlborough Downs as their common backdrop. The villages round and about Marlborough have changed little. Many of the scenes depicted in this publication are largely intact. Denser trees may have grown up around the church in West Overton, and the stately elm in Ramsbury may have been replaced by a young sturdy oak, but the local buildings endure, many constructed from the same sarsen stone as the famous monoliths around them. The Romans have also left their signature in the landscape around Marlborough; there is a major Roman crossroads at Mildenhall linking Old Sarum, Bath, Cirencester and Winchester. Part of an important settlement has been excavated here, close to the modern village.

The villages of Ogbourne St Andrew and Ogbourne St George lie undisturbed in the valley of the River Og. Like their neighbours, the buildings have been patched up in brick rather than rebuilt new. To the east and south the red brick and timber villages of Ramsbury, Great Bedwyn, Burbage, Milton Lilbourne, Wootton Rivers and Wilcot lie more or less away from the downs and the natural supply of stone. Savernake, a wooded parish, is crossed by great avenues lined by stately beeches and oaks. Tottenham House, ancestral home of the Seymours when they left Marlborough, lies hidden in the forest. Visitors to the villages may remark how little has changed from the time of Frith's photographs compared to the bustle of Marlborough. Indeed, although time has not stopped, it seems to have slowed down considerably at the end of the 19th century in these satellite settlements with the advent of the car. The photograph of Avebury in 1908 in particular illustrates poignantly how simple life once was.

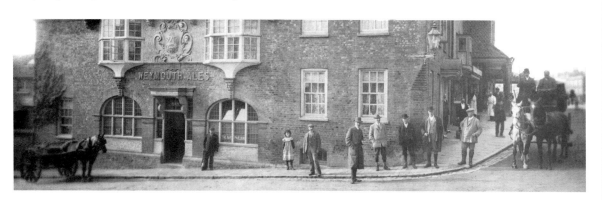

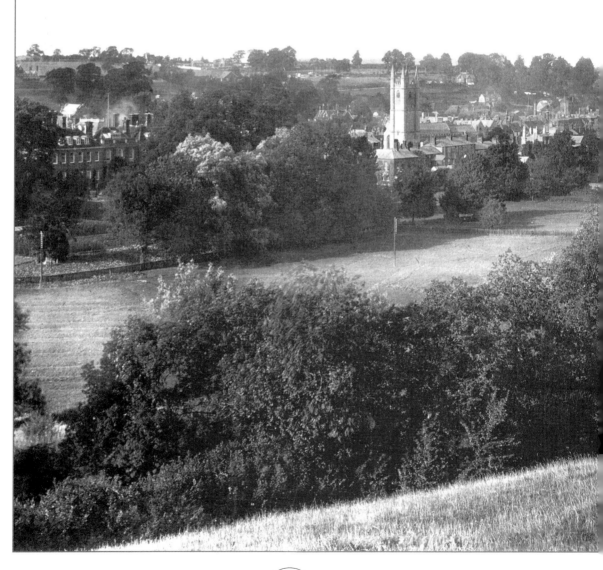

Marlborough

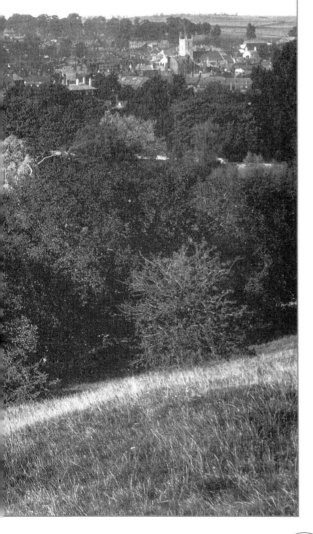

The View from Granham Hill 1901 47653
The whole of old Marlborough is visible; we can
glimpse the back of C House through the trees on
the left, and St Peter and St Paul's church is in the
centre; we see St Mary's rather shorter tower on
the right of the picture. Beyond the town are the
Marlborough Downs.

▼ From Salisbury Hill c1955 M34084

This view of the St Margaret's Mead estate looks from the south-east over the now dismantled railway. These prefabricated 'Cornish Unit' houses were put up around 1946. In the foreground is a deep track, one of the mediaeval hollow ways with which Salisbury Hill is scored.

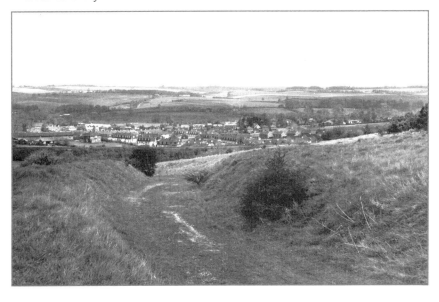

▼ White Horse Hill 1901 47667

Rather more hidden than most White Horses, this example was cut in 1804 by the pupils of Mr Greasley's boys' school in Marlborough. A common misconception is that the Horse was connected with the founding of Marlborough College, which is nearby.

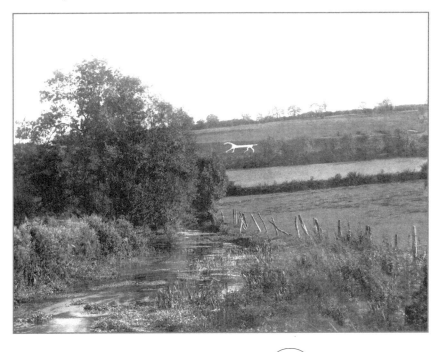

▲ From Duck's Meadow 1907 57845

The dilapidated farm buildings in the foreground have long since been replaced by modern development. Just below them is Cow Bridge, which crosses the Kennet and leads to the Pewsey Road. It was rebuilt in 1924 to cope with increasing traffic. The backs of the College buildings are to the left o it. In times past scolds were ducked here.

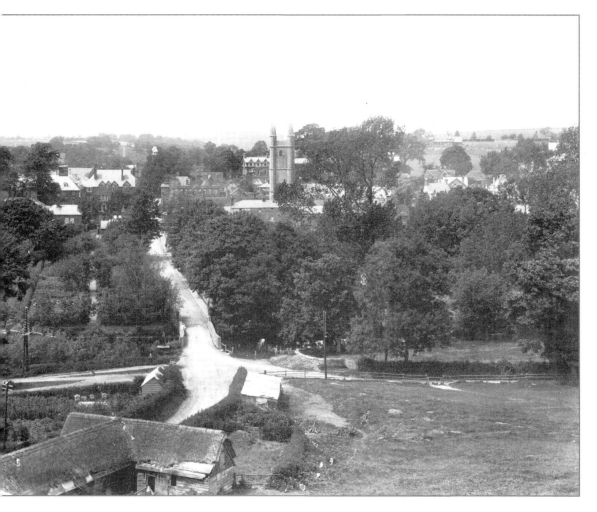

◀ **Treacle Bolley 1907** 57849
This spot is popularly
said to have been named
after a local miller in the
mid 19th century who used
to urge his fat, mottled pony
on with the entreaty· 'Git
up, old treacle bolly (belly)'.
After that time, College
puddings of the heavy
variety became known as
bolly. Kings Mill in the
background has gone.

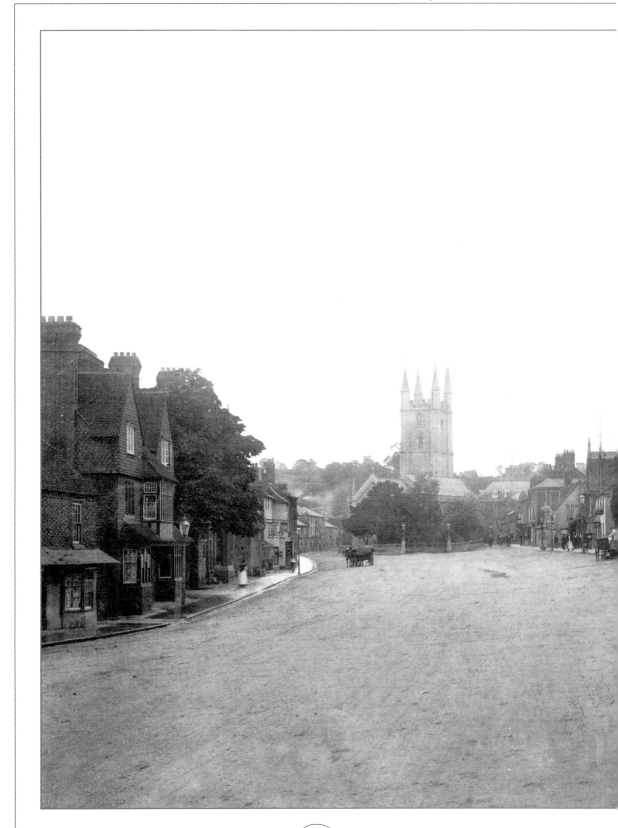

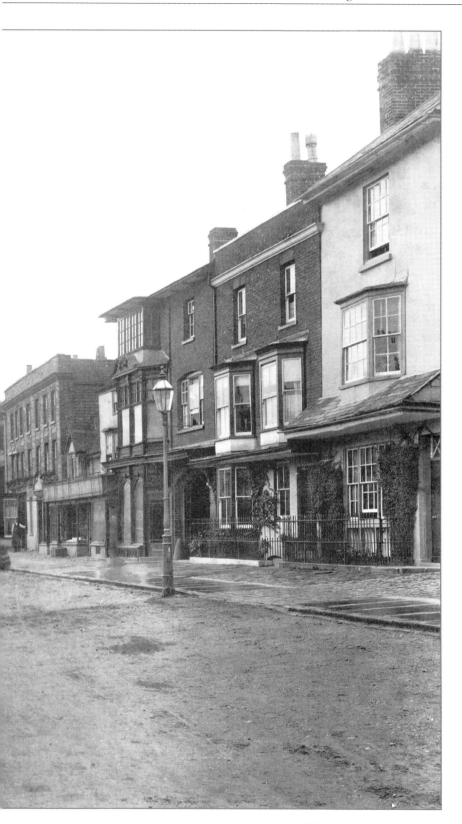

High Street 1901
47654
This photograph, empty of traffic and the ever-present parked cars, well illustrates how spectacularly wide Marlborough's High Street is. The first markets for which it was eminently suited were granted by King John and held in 1204.

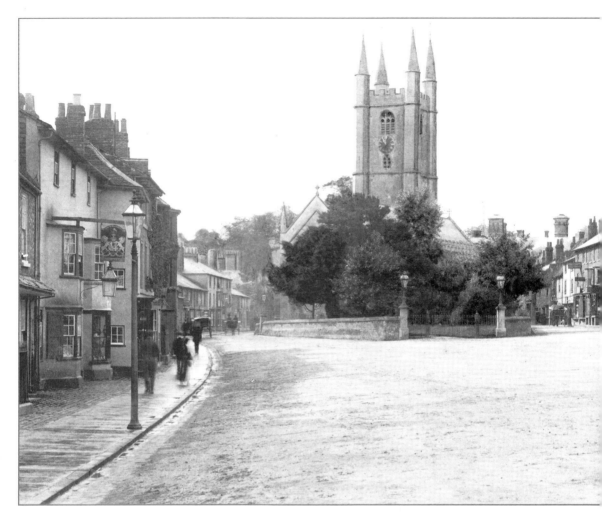

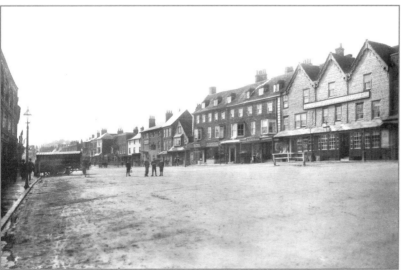

◄ **High Street 1901** 47657
The Castle and Ball Hotel, an
old established commercial
hotel and posting house on the
north side of the High Street,
has a distinctive tile-hung front
with pierced barge-boards
decorating the three gable ends.
These have since been replaced
with plainer examples, although
the balls finishing the gables are
still there. On the ground floor
is a pentice, a common feature
of the High Street frontages,
which must have kept many a
market trader and his
customers dry. In the road are
the corn rails - these were
removed in 1929.

High Street 1901
47655

The west end of the High Street is bounded by St Peter and St Paul's Church, dating from the mid to late 15th century. Its impressive four-square tower stands reinforced by octagonal turrets capped with 18th-century pyramids. Today the tower is not so visible, because the trees have grown larger.

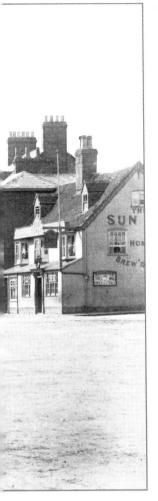

The Town Crier c1900
M34501

This rather stern-looking gentleman wearing his best frock coat and gaiters is Isaac Waylen, Town Crier and School Attendance Officer between 1889 and 1911, who lived in St Martin's. He poses with his official hand bell and a notice ready to read.

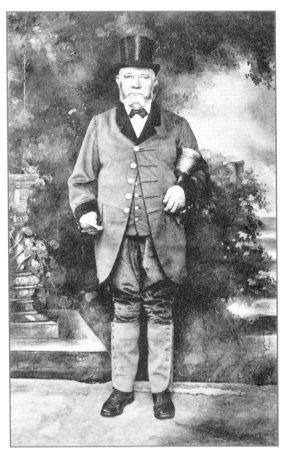

High Street 1902
48636

Dominant in this photograph of the east end of the High Street is the Town Hall, which at the date of this photograph had just been rebuilt by local architect C E Ponting. The earlier building of 1793 was smaller, with an open colonnaded area beneath through which the public had right of way.

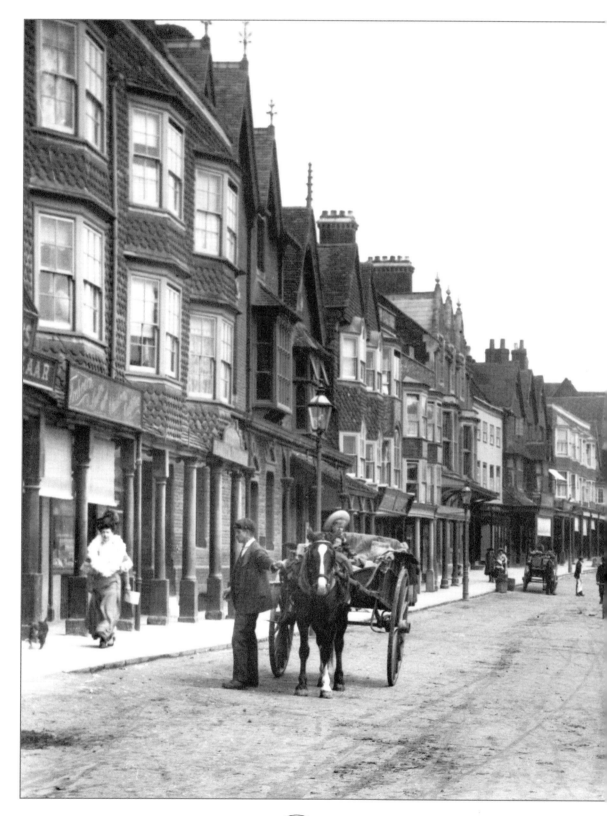

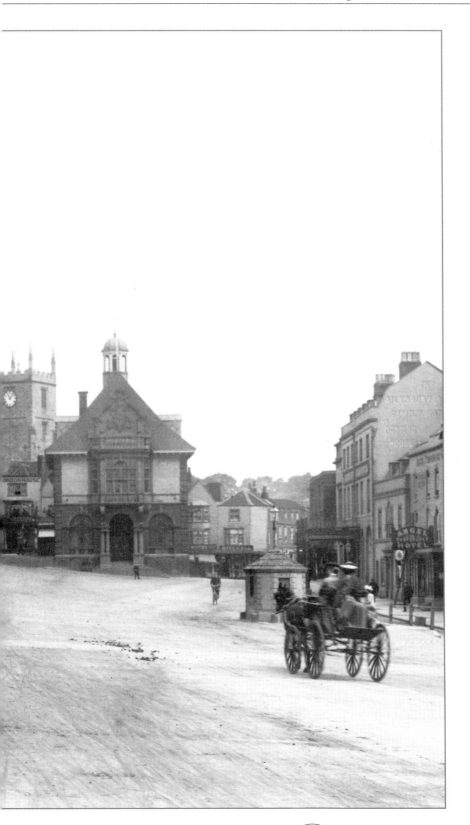

High Street 1907
57846
This view of the
High Street has
changed little from the
earlier scene in 1902
(48636, page 23).
Captured on the right is
the town lock-up or
blind house just behind
the moving cart. It was
rebuilt in 1854. Only
eleven of these curious
little buildings survive in
Wiltshire; they were
used to lock up the
18th- and 19th-century
equivalent of lager louts
for the night.

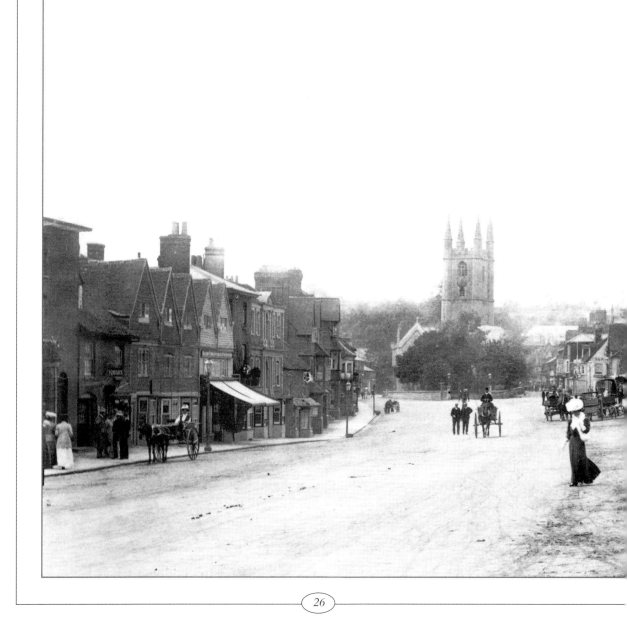

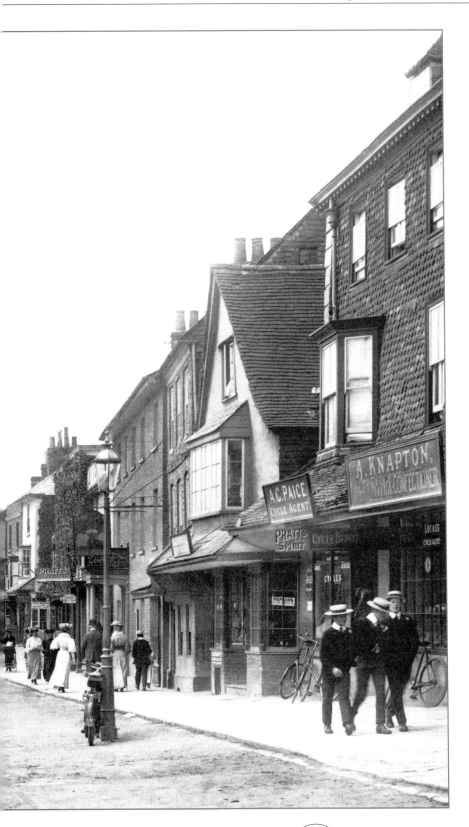

High Street 1907

57847

A group of boys in uniform and summer straw boaters stroll past Arthur Knapton's bakery and confectionery shop. A G Paice, cycle agent, leans his latest models against the wall. H Duck, who was running his business there in the 1960s, was still dealing in bicycles as well as toys.

▼ High Street 1910 62455

Another view of the east end of the High Street. On the right is the Ailesbury Arms Hotel, now the Ailesbury Court, dating from the early 19th century. Sharing the same building, and reached through the carriage entrance, are the Headquarters of the Royal Automobile Club. To the left of it are 2-4 High Street, home of Thomas Hancock (1768-1865) and Walter Hancock (1799-1852), inventors of vulcanised rubber and the passenger steam road carriage respectively.

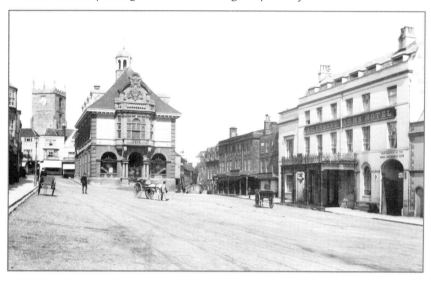

▼ The Priory 1910 62457

Set back from the High Street is The Priory, an early 19th-century Gothick mansion, built on the site of an earlier house belonging to the Carmelites, or White Friars. Now a retirement home, Marlborough College used it as an out-boarding house at this time. Note the impromptu tennis court in the foreground with garden rollers standing at the ready.

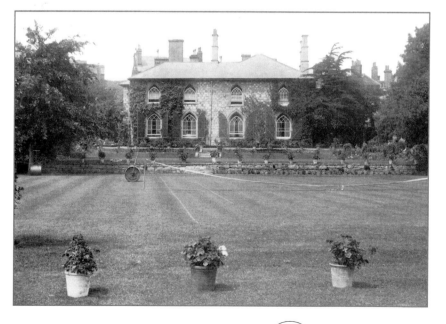

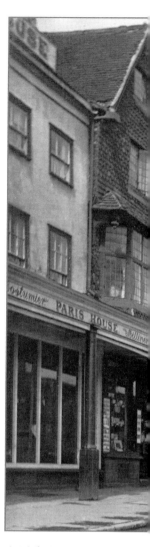

▲ High Street 1923 74450

From the left, the shops are Paris House, costumiers and milliners, and then Lucy & Co, stationers. The block with the bay windows contains Thomas Perry Bane's chemist, Dale & Co, ironmongers, and Edward Chandler, saddler and harness maker.
Two people have paused under a sign reading 'Halliday Antiques'. Note that a solitary car has now appeared on the streets previously devoid of them.

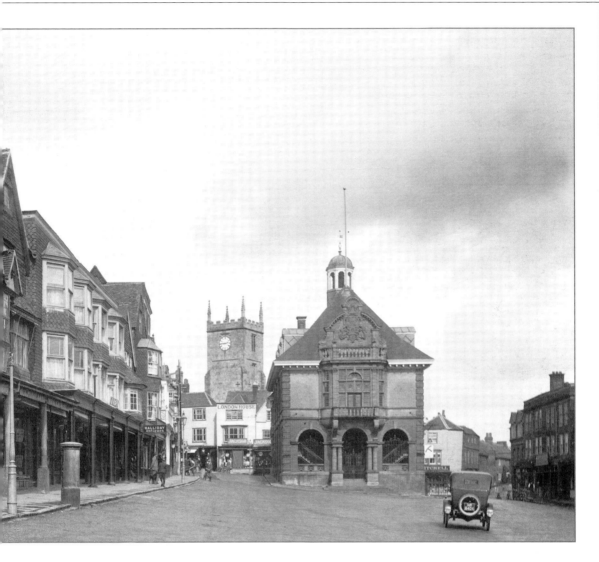

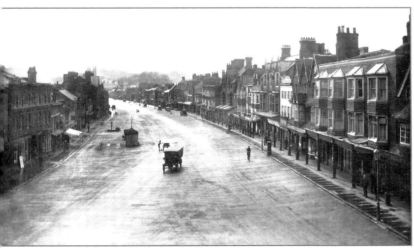

High Street 1923 74453
This photograph was evidently taken from the roof of the Town Hall after a shower. This is one of the last views which include the blind house and the weighbridge next to it. By 1929, both had been removed to accommodate increasing levels of traffic. We can see several motor cars down the street, and there is not a horse and cart in sight.

▼ High Street 1923 74454

The Castle and Ball's distinct round finials are visible on the right. In 1923 it described itself as a 'country hostel'. Adjoining it at No 119 are Flux & Co, booksellers, stationers, newsagents, circulating library, fancy goods dealers, picture framers and relief stampers.

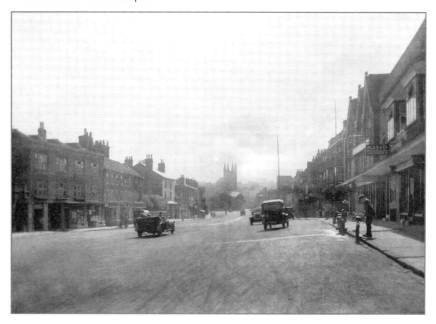

▼ High Street c1950 M34010

A jump forward in time of 32 years from photograph 74454 reveals the centre of the High Street marked out with the familiar and constantly-occupied parking bays, though parking was still permitted along the kerbs. Flux & Co still have their original sign up. The white-painted building on the other side with tall chimneys is Waterloo House, now gone.

▲ High Street c1950

M34011

The five-gabled building on the left was built after the Great Fire of 1653, which started at the west end of the street after oak bark used in the tanning process caught fire. The fire destroyed 150 buildings on both sides of the High Street and parts of Silverless Street, Kingsbury Street, Oxford Street and The Green. Another fire destroyed the building in 1975, and it has been replaced with a grocers and bookmakers. H Duck's shop still flourishes, now selling toys.

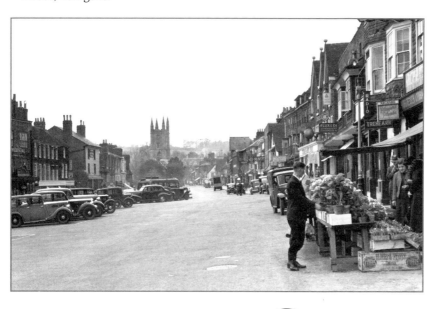

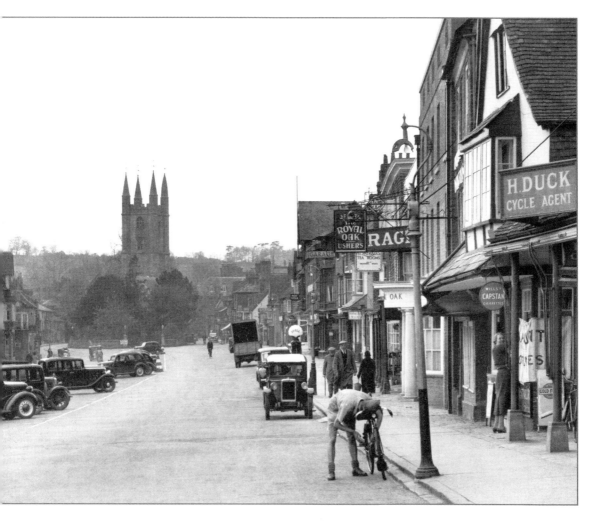

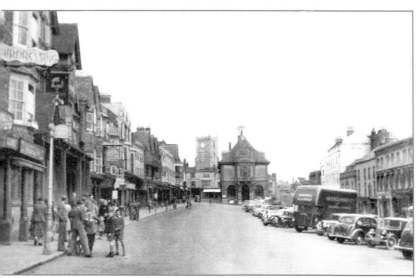

High Street c1950 M34019
This rather grey and
somewhat unfocussed print
was perhaps taken in a
hurry owing to the
unwelcome attentions of a
group of schoolboys close
by. The large parked van
belongs to Arding & Hobbs,
Removals and Storage.

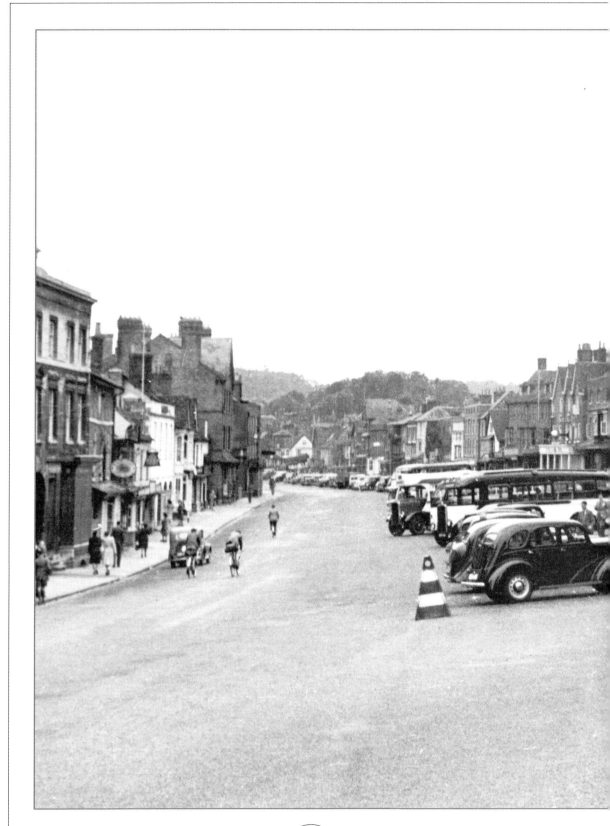

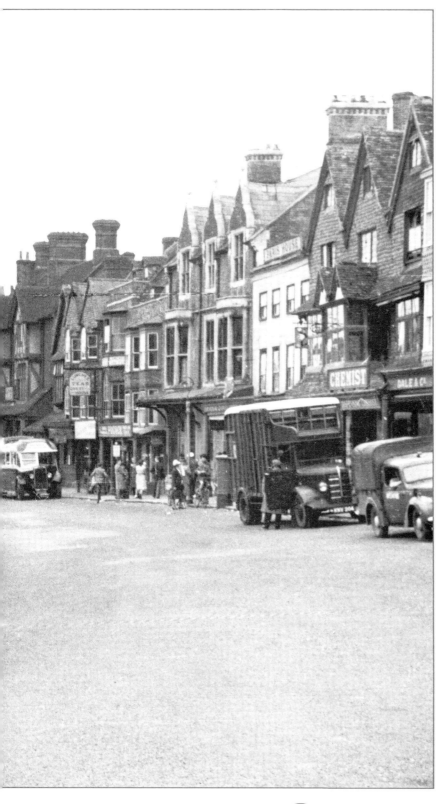

High Street c1950
M34023
The amount of traffic
has increased, with
lines of parked cars
obscuring the shop
fronts. With greater
mobility, the age of the
tourist had arrived; day-
trippers' charabancs
mix with local service
buses. Note the
wooden traffic cones.

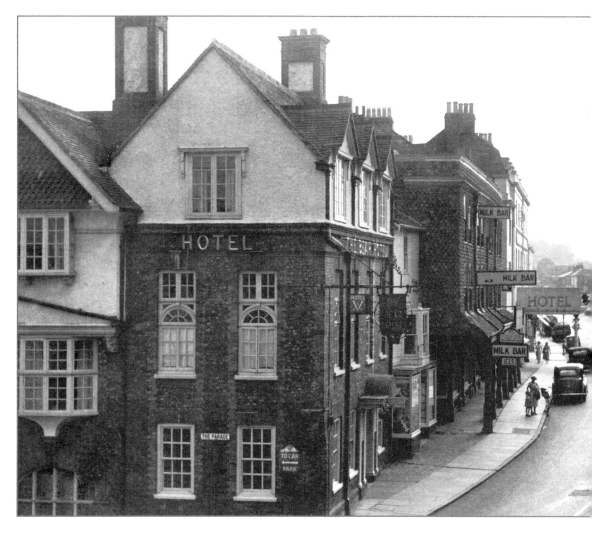

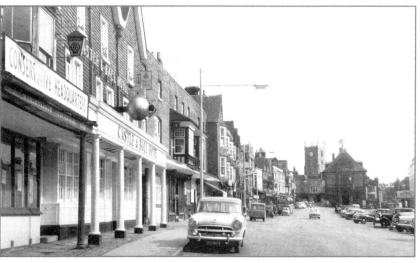

◄ **The Castle and Ball Hotel, High Street c195**

M34091

Ugly new street furniture in the form of electric street lamps begin to make an appearance. The Castle and Ball Hotel has lost its decorative tile-hanging and barge boards; instead, a huge metallic ball is suspended over the pedestrians. On the left, the Draper's and Tailor's shop we saw in 1901 has been replaced by Marlborough Conservative Club.

High Street c1950

M34053

This view was taken from St Mary's Church. Tucked in behind the Bear is an early 19th-century rebuilding of a timber house, which may have survived the Great Fire. It probably had a jetty like that at Dormy House in Kingsbury Street. The building beyond, 2-4 High Street, is dated 1739, and was at that time a milk bar.

The Polly Tea Rooms c1955

M34103

This Georgian building, photographed before it was partly destroyed by fire in 1966, houses the Polly Tea Rooms, which were established in 1928. The first and second floors on the left have been removed, leaving the ground floor and right-hand part intact. In 1722 this building was the Half Moon pub, which shut in 1815. The late 18th-century building on the left has gone.

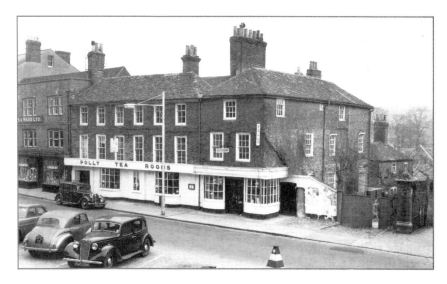

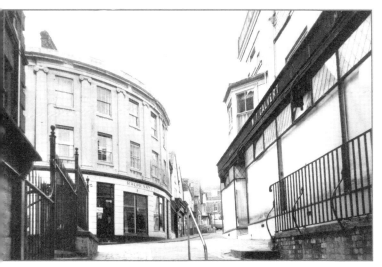

Passageway to the High Street c1965 M34125

Enclosed by railings, a modern handrail of tubular metal has been added for the comfort of pedestrians on the steep hill. Ahead in the curved early 19th-century building is Ralph Say & Son, outfitters and drapers - an older business, W T Calvert, general draper, has just closed down.

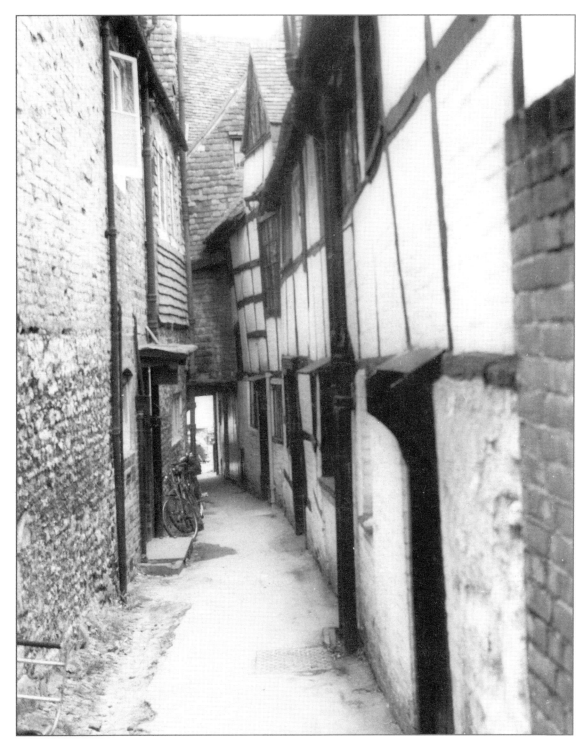

Chandler's Yard c1965 M34133
Once known as Horsepassage Yard, Chandler's Yard is reached through an archway between 136 High Street, The White Horse Bookshop (where Chandler, a saddler, had his shop), and 137, Crispin House. The old timber-framed cottages date from the 16th century.

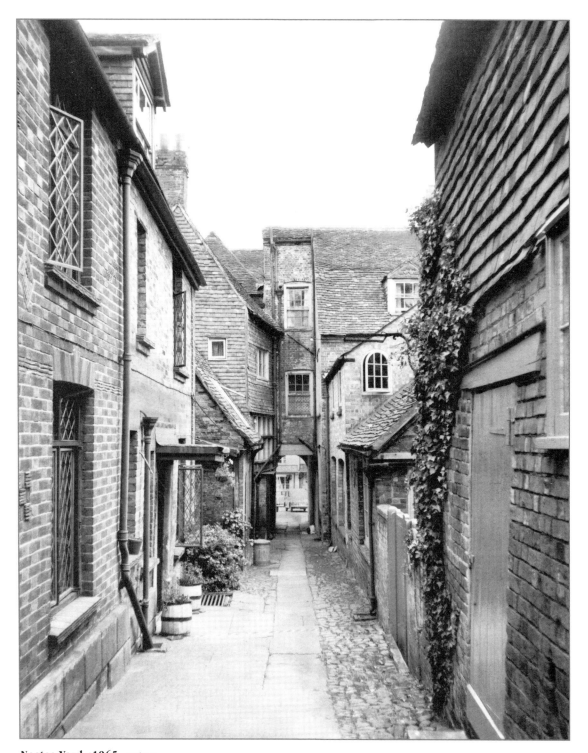

Neates Yard c1965 M34122
Neates Yard is reached between 120 and 121 High Street. This pretty passageway to the High Street is unaltered today, even down to the original paving. It was here that the Neate brothers lived and ran their funeral home and carpentry business in the later 19th century.

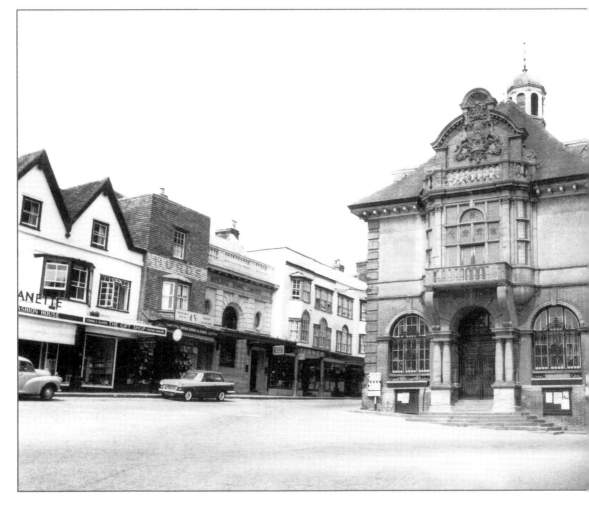

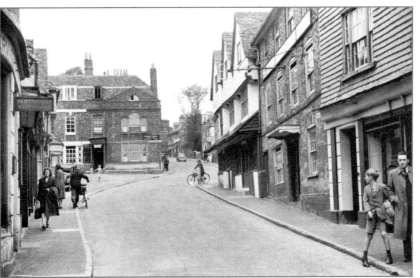

◀ **Kingsbury Street c1950** M34036
A schoolboy's attention has been caught, perhaps by the girl running after her ball in front of the Kingsbury Arms Hotel. This important listed building started life as the George, which closed in 1822. The Edwardian blue brick paving is a rare survival to this day.

The Old Town Hall
c1965 M34130
More street furniture has crept in. We can clearly see the signs on the front of the Town Hall, which were added before 1955. On the left is the Midland Bank, built in 1922. On the left of it is Owen Hurd & Sons, described as 'footwear specialists'. On the right of it is H A Turner, who sold both bicycles and guns!

An Old House ▶
Kingsbury Street
c1955 M34052
Now known as Dormy House, this house was rebuilt after the Great Fire. It has a timber frame hidden by stucco. The front undulates with three irregular projecting bay windows, which are skirted by the tiled pent roof sheltering the ground floor. The attic gables are jettied forward, a device favoured in narrow town plots to increase floor space.

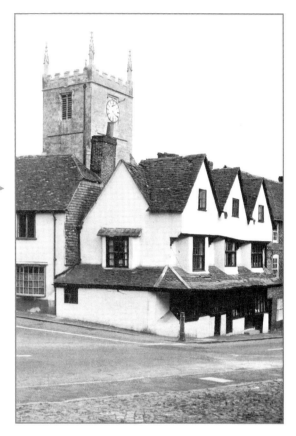

Kingsbury Street
c1965 M34121
This wider view takes in the junction with Silverless Street. Originally called Silver Street, this curious name's origins are thought to derive from the probable settlement of Jewish moneylenders, who were encouraged by Edward I, but were later thrown out by the Queen Mother in 1275.

▼ **Oxford Street c1965** M34120
No 23 and 24 The Green is a 16th- or 17th-century timber-framed house; it is relatively unchanged, except for the decidedly-modern leaded windows and television aerial. The more modestly-placed Marlborough Labour Club has a pair of 19th-century terraced houses as its headquarters.

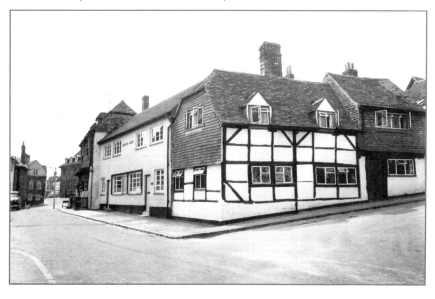

▼ **The Green 1902** 48638
The west side of The Green is made up of 16th- and 17th-century cottages backing onto St Mary's churchyard. The brick houses on the left are all 18th-century. William Golding, the novelist, lived in the house immediately to the right of the church from 1911 until 1993. His father was a master at the College.

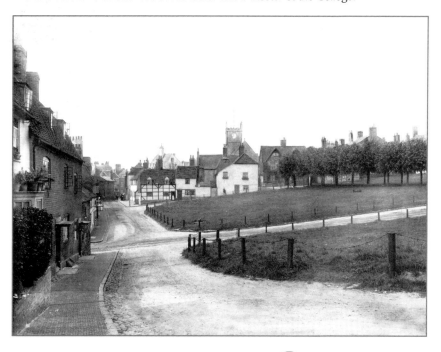

▲ **The Green 1902** 48639
Here we see the rather grand south side of The Green with its largish 18th-and 19th-century houses. George Harry Shackle, an architect, lived at No 9, the house with blinds drawn on the ground floor. Although it is now residential, a diversity of tradesmen and professionals carried out their business here around the time of the photograph. The Green was home to a road surveyor, several boot-makers, a whitesmith and tax collector, a builder and the White Hart pub.

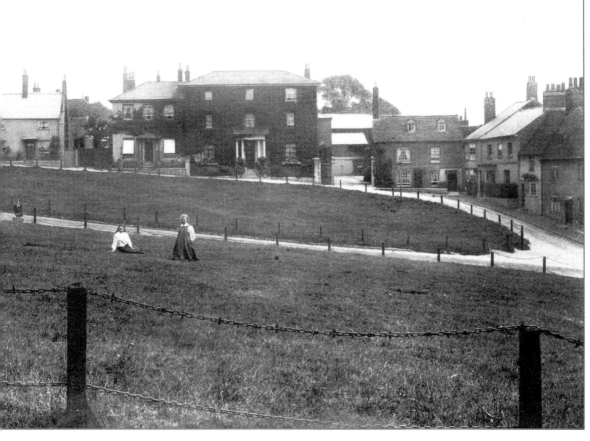

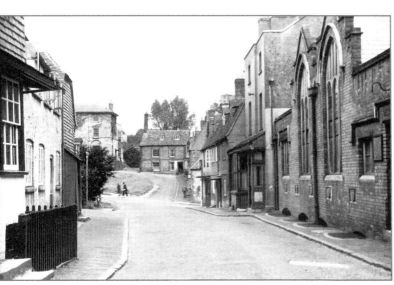

◄ **Oxford Street and The Green c1950** M34033
On the left is the Methodist Church, built in a loosely Perpendicular Gothic style. John Wesley preached on this spot in 1745 and 1747, but the first church was not built until 1816. It was extended in 1872, and the church was rebuilt completely in 1910. The buildings next to it are 18th-century. The tile-hung house opposite is 16th- or 17th-century.

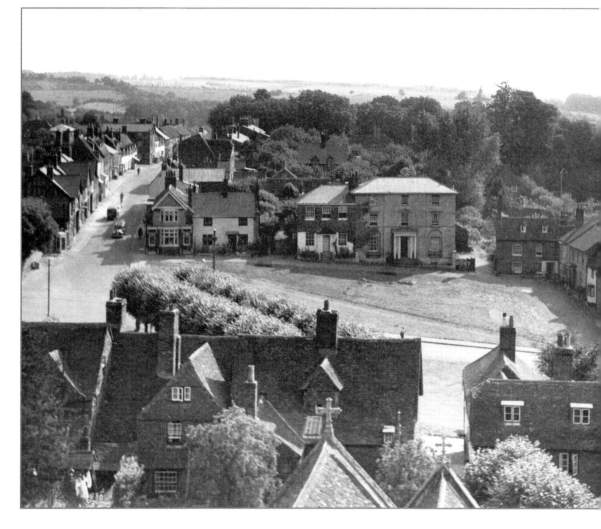

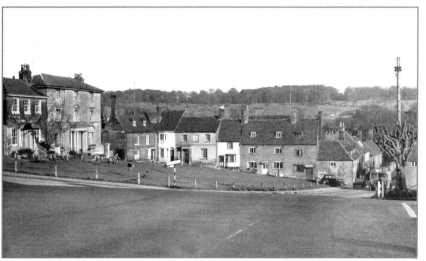

◄ **The Green c1955**
M34078
A bus labours up
Barn Street, with
Savernake Forest in
the background. This
peaceful scene with its
village atmosphere is
little changed today. It
was probably the oldest
part of Marlborough,
and the site of a Saxon
settlement.

The Green c1955 M34060
This view from St Mary's Church tower shows The Green, with its little avenue of limes, and St Martin's, a road of mainly 18th- and 19th-century houses leading to Mildenhall. It is named after St Martin's Chapel, which stood at the far end between 1254 and 1549. A stone from the chapel was found in a wall near the top of Poulton Hill, and now lies in Preshute Church.

St Martin's c1965 M34131
On the left are an attractive group of five Edwardian terraced houses. As is typical with Victorian and Edwardian houses, they bear a wealth of detail, including tile-hanging, jettying, false timber-framing and oriel windows. Note that it was still possible to stand in the middle of the street and have time to set up a photograph.

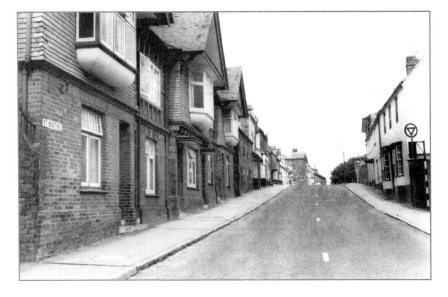

The Bear and Castle Hotel 1906 57184
This exuberant display of late 19th-century architecture is by Crickmay of Weymouth. At the entrance to the High Street from the north-east end, the building presents a bewildering mass of architectural detail; every pair of windows are different on each storey. From 1949 the hotel was known by its present name, the Bear.

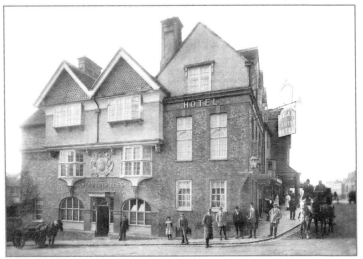

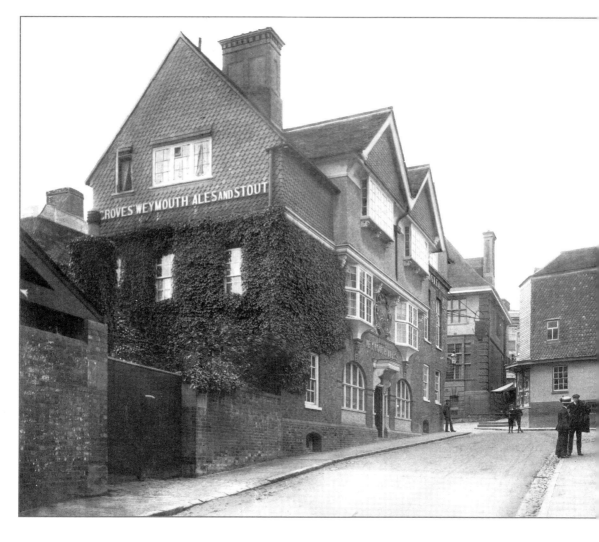

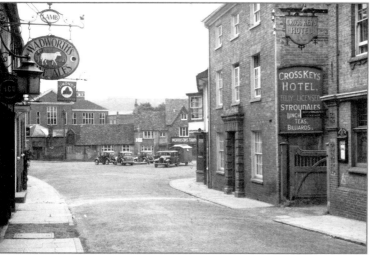

◄ **The Parade c1950** M34022
The Cross Keys Hotel was known
as the Cross Keys and Unicorn from
1768. The present building is later;
it perhaps dates from 1904, when
the name was shortened. It closed
in 1974, and is now known as
Marsh House. Opposite is the Lamb,
which first made its appearance on
this site between 1672 and 1781.
The present Lamb opened in 1833.
In the centre on the right is
Morrisons tarpaulin and rope works,
established in the town for at least
250 years. Centre left is St Peter's
and St Mary's Junior School, which
stands on the site of the ancient
St John's Hospital.

The Parade and the Bear and Castle Hotel 1910 62456
Another view of the Bear and Castle, this time from The Parade. Although they do not look it, the buildings opposite the Bear are ancient. They contain cruck trusses - a form of timber framing not seen in Wiltshire after 1500. At the top of the road is 48 High Street, another timber-framed building now hidden under 19th-century tile hanging and a modern shop front.

▼ **The Parade c1950** M34037
This view was taken from the High Street end; the Lamb and the Cross Keys hotel signs are just visible. Morrison's, now Katharine House, to the left and behind the Cross Keys, not only made tarpaulin and rope but also waterproof covers, tents, sacks, twines, halters, plough reins, nets of every description, and sash and blind cords. More recently, early wall paintings, including that of an angel and mermaids, were found inside during its conversion to a house.

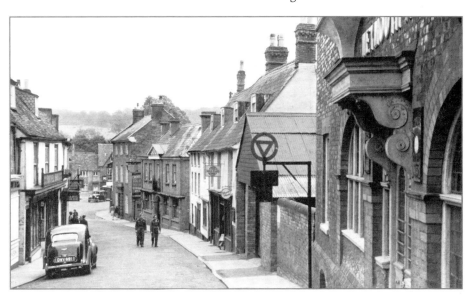

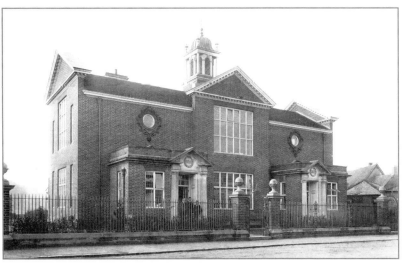

◄ **The Grammar School 1906**
57183
We see the school one year after it opened. Some of the Earls of Ailesbury attended school here. In 1853, Earl Bruce devised a scheme to amalgamate the College and the Grammar School, but it came to nothing. Note the separate entrances for boys on the left and girls on the right. The central gate has now been altered to two.

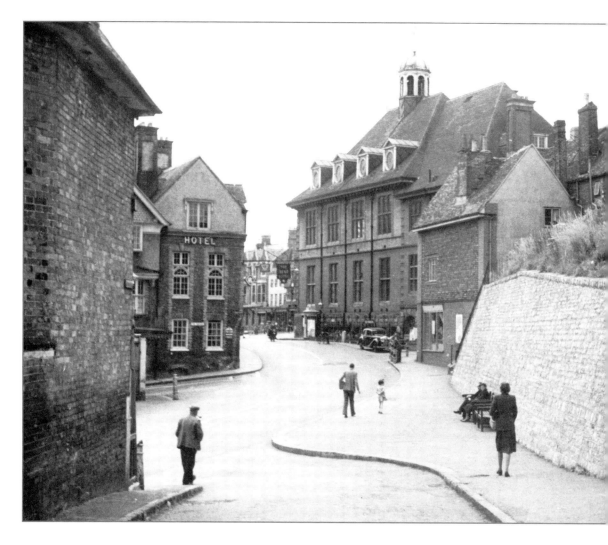

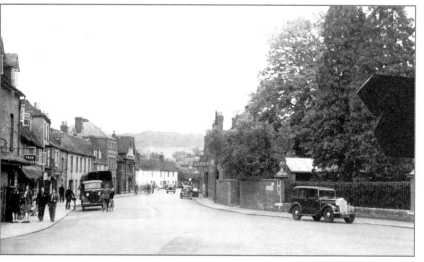

◀ **London Road c1950**
M34031
We are looking south-east towards Savernake. On the extreme left is D H Corneby, baker and confectioner. Further on is T C Baker, watch and clock repairer. The double-gabled Five Alls is beyond the car, and in the distance is a group of 18th-century cottages. On the right, a car is parked in front of listed railings belonging to St Peter's and St Mary's junior school.

The Entrance to the High Street from New Road c1950 M34034
New Road was made in 1812 as an alternative route to access the High Street. Previously the south approach at the east end was through The Parade, which had a steep and awkward bend. Behind the Town Hall are a group of houses rebuilt after the Great Fire.

The War Memorial and the Church c1950
M34032
This is the junction of New Road and Barn Street. The memorial was raised by the 7th Battalion of the Wiltshire Regiment in 1919 to commemorate the 360 men who died during World War I. It was added to in 1946. The neat wall and steps have now gone. On the left is an agent's sign for Ferguson's Farm Aids.

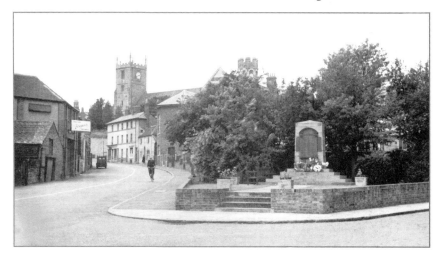

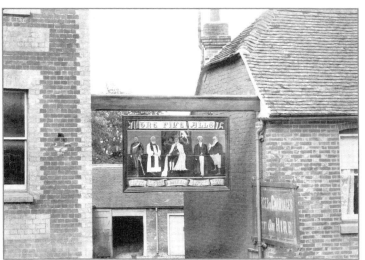

London Road, The Five Alls 1907
57850
The Five Alls in the London Road sports this satirically humorous sign: 'I fight for all, I pray for all, I rule all, I plead for all, I pay for all'. The sign has its origins in the 17th century, though the figures here are rather later. Quite often the faces were portraits of well-known local people.

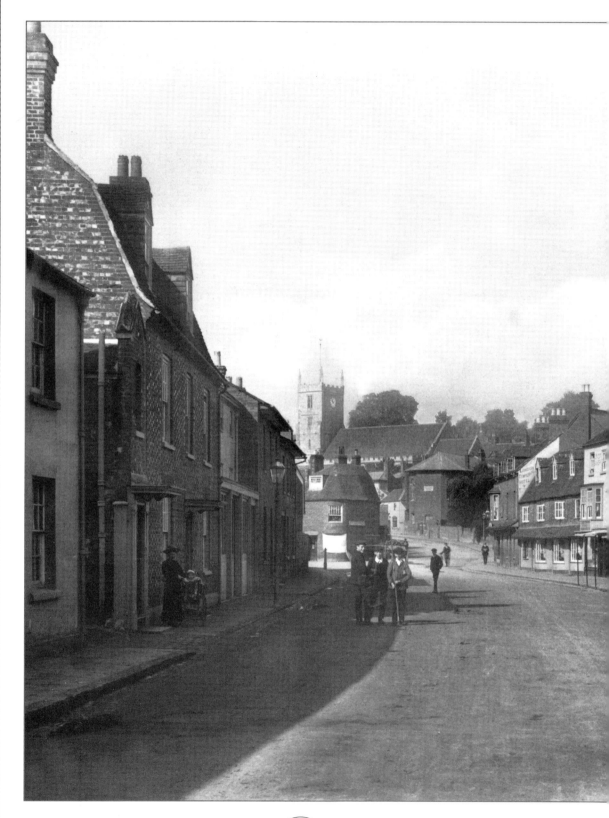

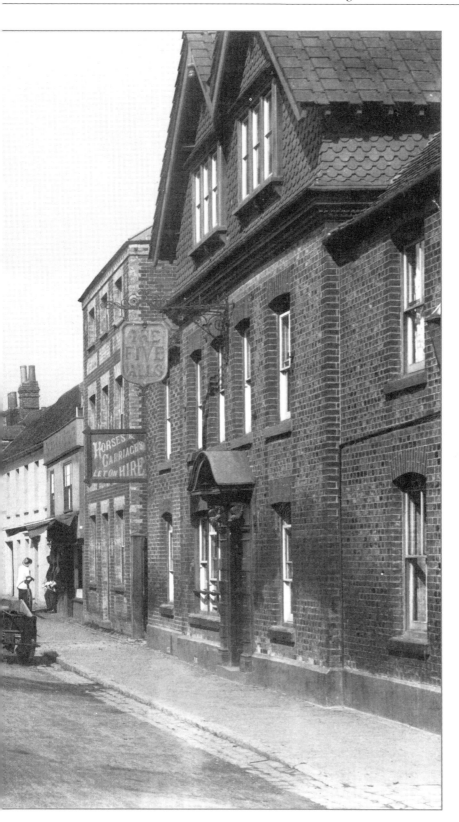

London Road 1908
60943
We are looking towards
St Mary's Church. The
three-storey building
on the far right is the
Five Alls pub, dating
from 1748. The street
front was altered in the
late 19th century, giving
a crisp appearance,
particularly to the
double-gabled roof.
The sign stuck on the
corner reads 'Horses &
Carriages let on hire'.

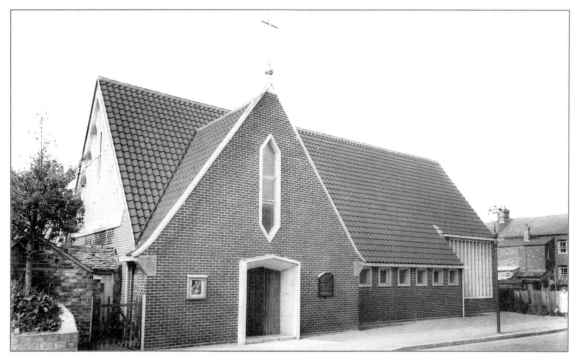

The Roman Catholic Church c1965 M34124
Before the new church of St Thomas More was built in George Lane in 1959 on the site of the Old George Inn,
Catholics in Marlborough had to go to the Bonita racing stables at Ogbourne Maizey, where the Missionary Priest
in charge at Devizes presided over mass.

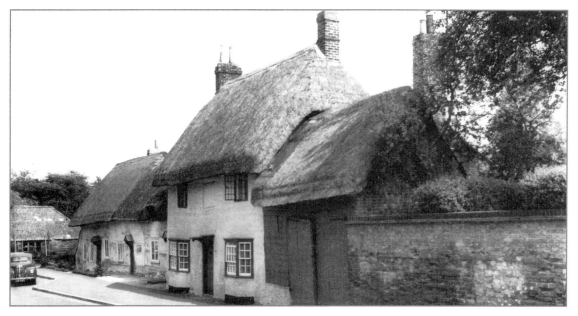

George Lane c1965 M34135
Before George Lane was built up during the earlier 20th century, it was a narrow wooded way known as Love
Lane. The tallest of the cluster of thatched cottages at the east end of the lane is 18th-century. The lower row is
16th-century and timber-framed.

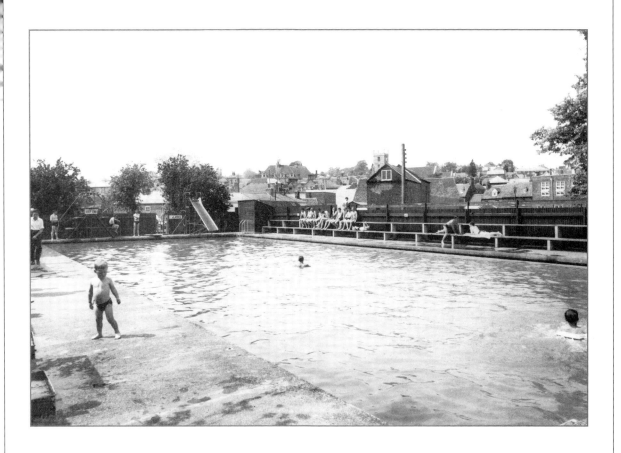

The Swimming Baths c1965 M34129
Long before the leisure centre at Barton Dene was built, the
municipal open-air heated swimming pool at Lady Bridge opened
in 1937. In 1960 the entrance fee was 6d for adults and 2d for a
child or a spectator.

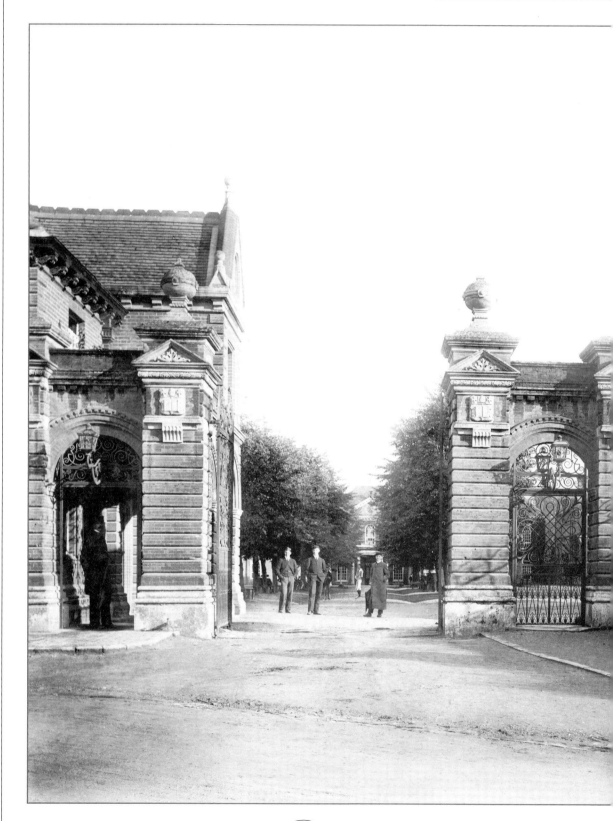

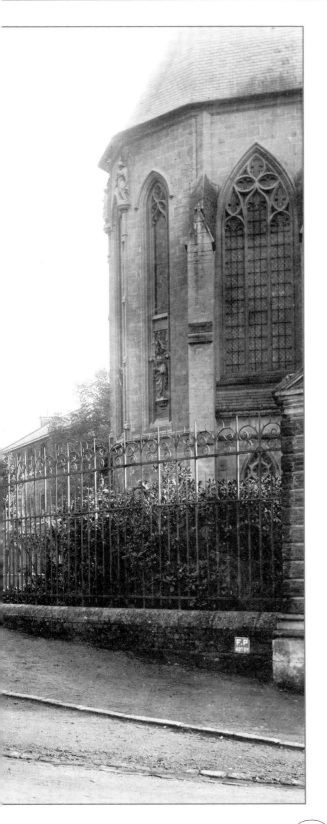

Marlborough College

The College 1901 47658
Pupils and staff pause at the magnificently
Baroque entrance gates designed for the College
between 1876-77 by G E Street. Hidden in the
shadows of the equally ornate Porter's Lodge is
perhaps the porter himself. We can just glimpse
C House through the trees.

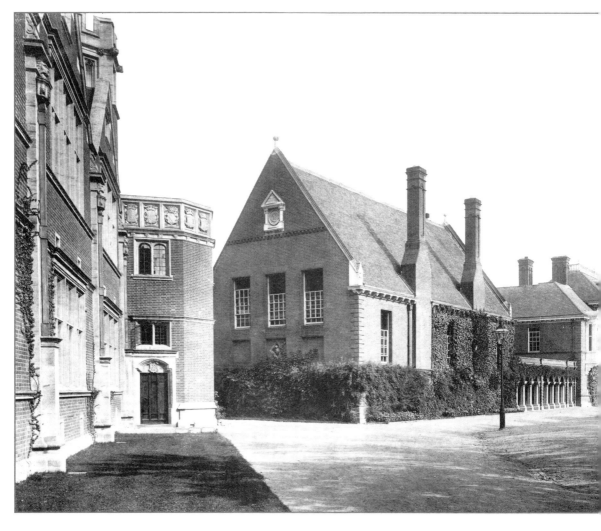

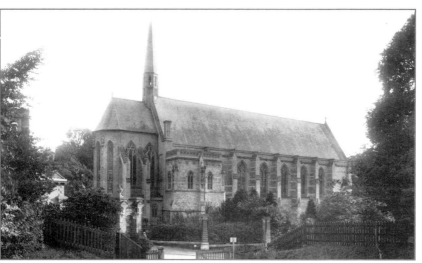

◀ **The College Chapel 1901** 47663
The present Gothic-style chapel of St Michael and All Angels was built between 1883-86 at a cost of £31,000 by Bodley and Garner. It stands on the site of an earlier chapel by Blore, and some of the original stone was reused.

The College, the Bradleian Building 1901 47660

This steep-roofed brick building with rather a Gothic flavour, designed by G E Street, replaced a block of fives courts. It commemorates the name of one of the College's headmasters, George Granville Bradley (1858-70). He followed Dr Cotton in increasing the size of Marlborough from a modest establishment, providing good cut-price education to the son of clergymen, to one of the great public schools of the time.

The College Chapel 1901 47664

This view looks east. The chapel was not considered an architectural success, and its interior has been described as 'barn-like'. The lack of a screen between the main body of the church and the altar probably adds to the effect.

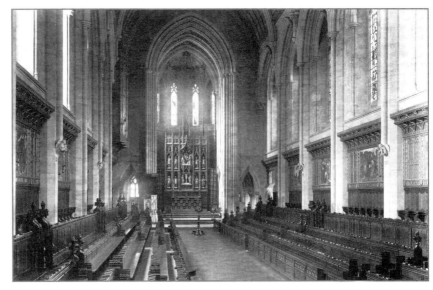

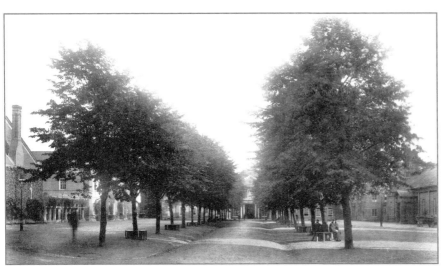

The College Avenue 1901 47665

A shady spot suitable for scholarly discussion or common-room gossip, this avenue of lime trees, their bases encircled by benches, replaces a circular drive and lawn in front of C House. The building on the right of the picture is the Old Dining Hall, now gone.

▼ **The College, Cotton House 1901** 47666
This view was taken from the far bank of the River Kennet. Cotton and Littlefield were new houses constructed a little way from the main College complex on the Bath Road. They opened in 1872, creating some rivalry between 'college' and 'outboarders'.

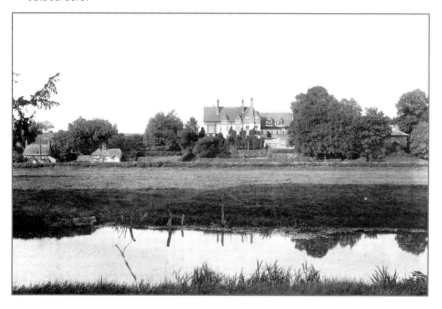

▼ **The College, North Block 1901** 47661
This building's architect was Thomas Garner. This Tudoresque classroom block was begun in 1893, though it was not completed until 1899. It replaced the fives courts, old racket court and a bat-fives court - some of them were rebuilt elsewhere. A Jubilee Racket Court was presented by Old Marlburians.

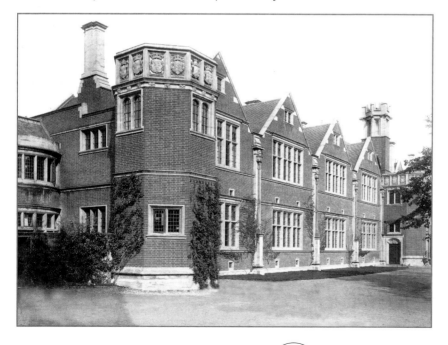

▲ **The College, A House the Dining Hall and the Chapel 1902** 48641
In 1844 the newly-formed Council of Marlborough College raised £10,000 to adapt the old school buildings and to enlarge the school. A House, the three-storied building, was completed in 1850 to Edward Blore's designs. Behind it is the original dining hall, also by Blore; this has since been replaced by one built c1960.

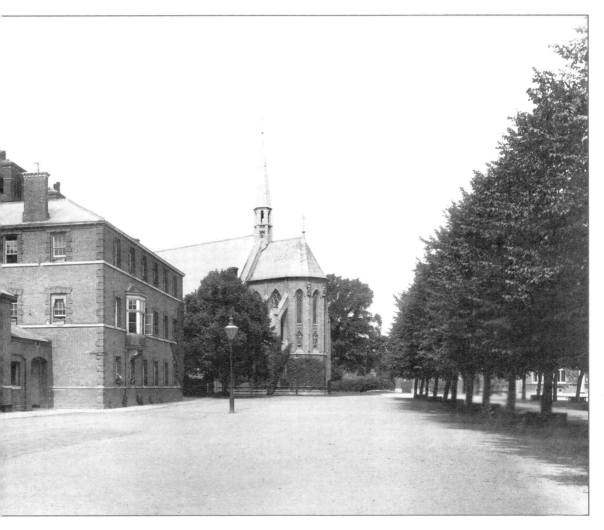

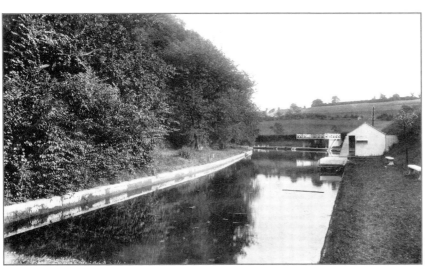

◀ **The College, the Bathing Place 1902** 48645
It is thought that the Bathing Place is on the site of the old ditch or moat that ran around the Castle Mound, hence its curved shape. Before the pool was made, the boys used to bathe above the mill at Treacle Bolly. In 1877 the pool was deepened and paved.

▼ **The College, Barton Hill House 1907** 57853
The expansion of Marlborough College during the 1860s was due to more money becoming available. Barton Hill, now a listed building, was designed and built in 1862–3 by William White as an out-boarding house. Its rather plain and even severe appearance is mitigated here by an extensive growth of ivy.

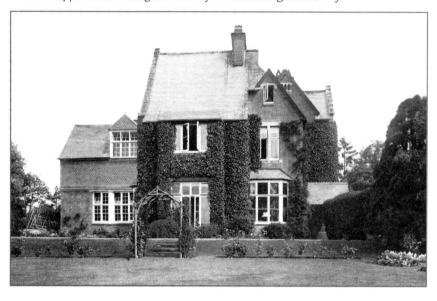

▼ **The College, Summerfield House 1907** 57854
Here we see another out-boarding house, this time in Hyde Lane. Summerhill is not a listed building, despite being built before 1886. It was enlarged between 1900 and the date of this photograph. Again, the stark brickwork is partially hidden, except on the new extension to the left.

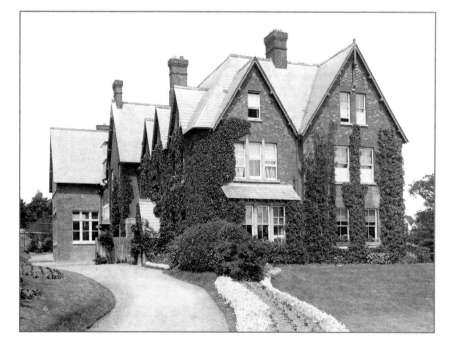

▲ **The College, Littlefield House 1907** 57855
Littlefield is in a similar vein, an imposing gabled boarding house built (surprisingly) of concrete, one of the earliest uses of this material. The architect G E Street designed the building using this revolutionary method, which was patented by Charles Drake in 1870.

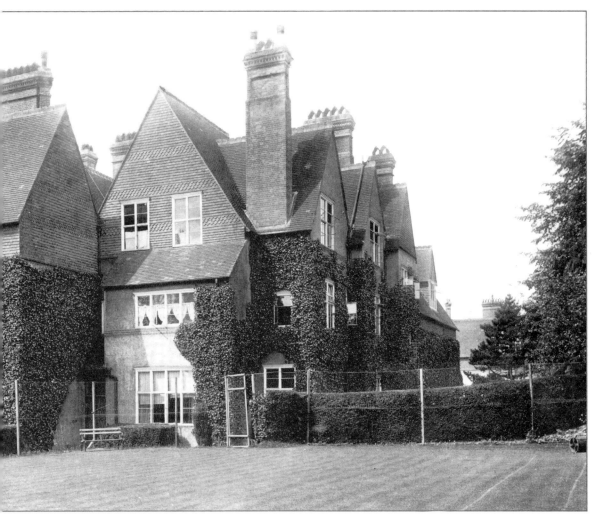

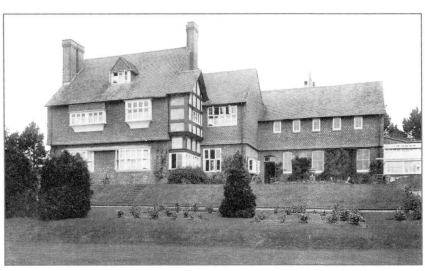

◀ **The College
Upcot House 1907** 57857
Upcot was geographically the furthest boarding house west of the centre of the College. It was designed by Richard Norman Shaw in 1886 as a master's house with a dormitory behind. The building is shown before the enlargement of 1927-28 was built to the east.

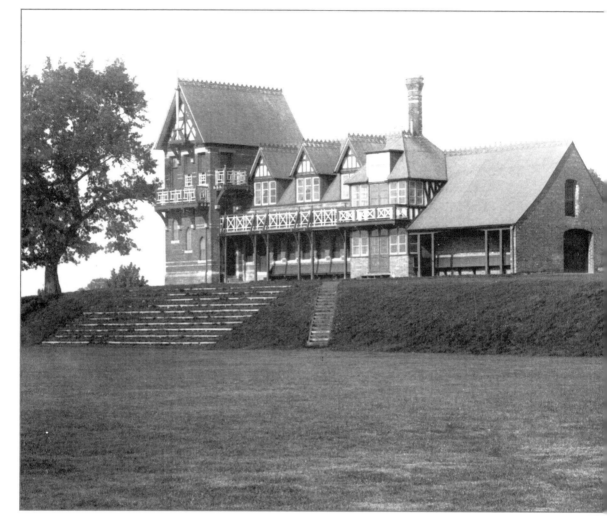

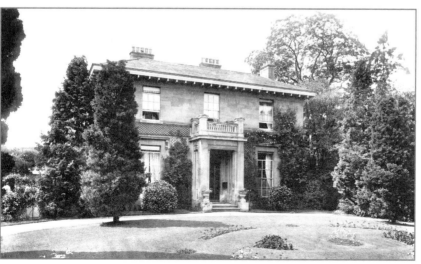

◄ **The College
Preshute House 1910**
57852
Built in the early 19th
century, Preshute House
was home to the
Rev P W Taylor, MA at the
time of this photograph.
The house presents a
facade softened by
climbers and shrubs
amid informal lawns.
It was assimilated into the
College not long after it
opened in the 1860s.

◄ **The College, the Sports Pavilion 1908** 60950
Standing on the edge of a sunken running track, this quintessentially Victorian building was erected as a cricket pavilion in 1874 on the site of an earlier one of 1856. It was built by subscription and presented by the Old Marlburians. The soil excavated from this area was used to partially fill in the moat around the mound.

▼ **The College 1923** 74456
Field House on the left, and the brick arch connecting it to the North Block, were completed in 1911. A third of the pupils were transferred here. Through the arch the building presenting a corner is the former Mount Inn, built in 1744. It closed in 1838, and was later used as a jewellery workshop by the College.

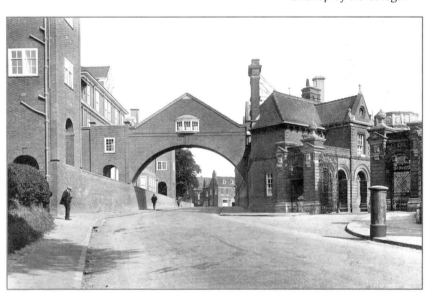

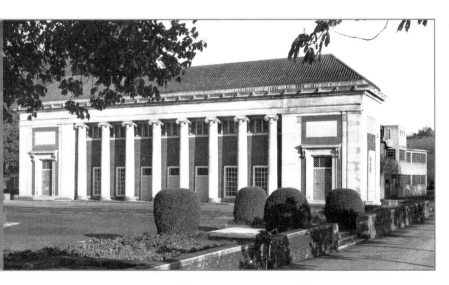

◄ **The College the Memorial Hall c1955** M34077
This impressive building with giant columns was designed by W G Newton in 1921. He was also responsible for the science laboratories and Leaf Block. The Duke of Connaught opened the Memorial Hall on 23 May 1925 in memory of the 750 Old Marlburians who died in the war.

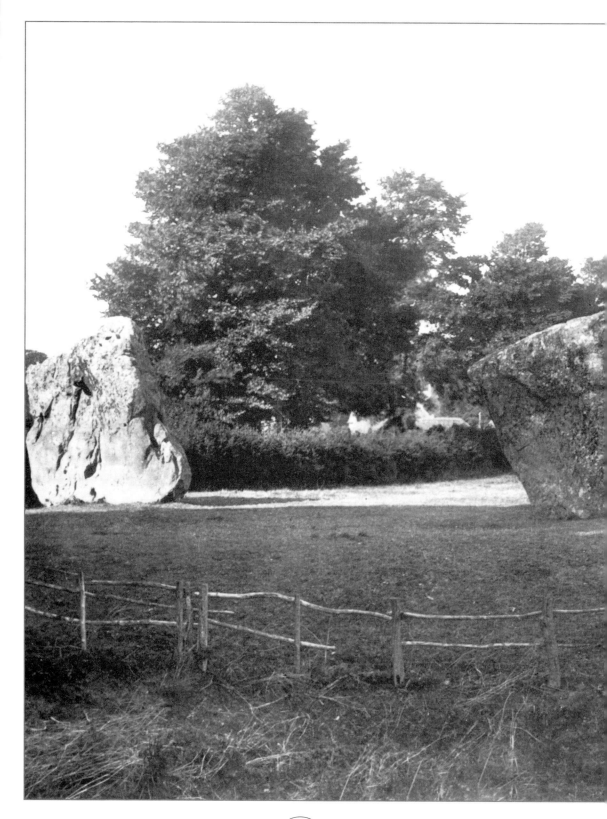

Around Marlborough

Avebury, The Stones 1899 44859
The two stones in the foreground are the southern entrance stones; part of the south circle lies beyond. The fallen stones were re-erected by the archaeologist Alexander Keiller in the 1930s. The Red Lion, its timber framing just visible behind a bush, is still a familiar building in Avebury to many visitors.

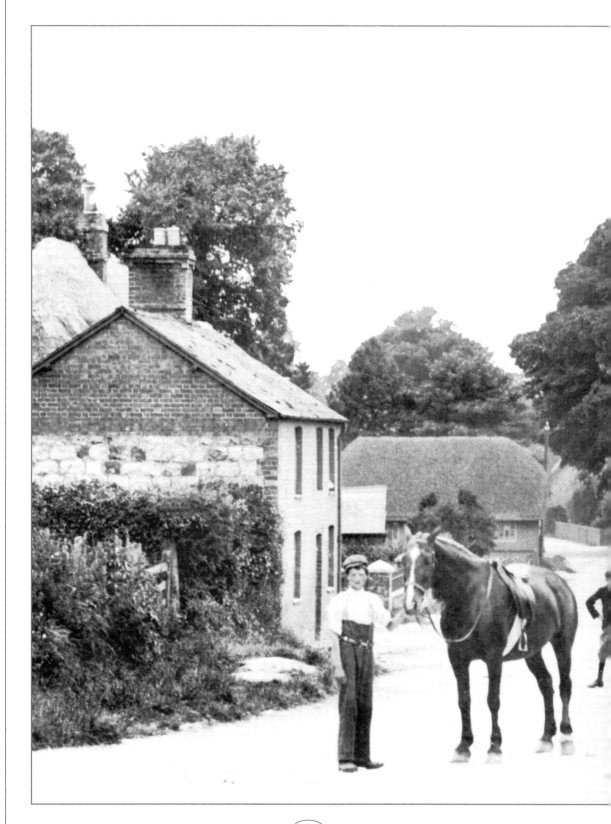

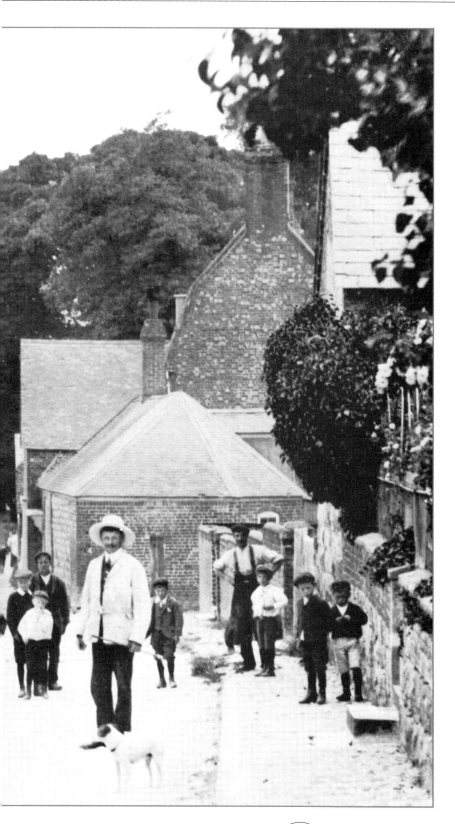

Avebury, High Street West c1908 A80002
This snapshot of Avebury villagers temporarily distracted from their everyday activity is in contrast to what might be seen today. The village swarms with visitors to the various gift shops; in 1908, some of them were working buildings. On the left is the post office, and behind the horse is Fowler's Forge. Many of these buildings now belong to the National Trust.

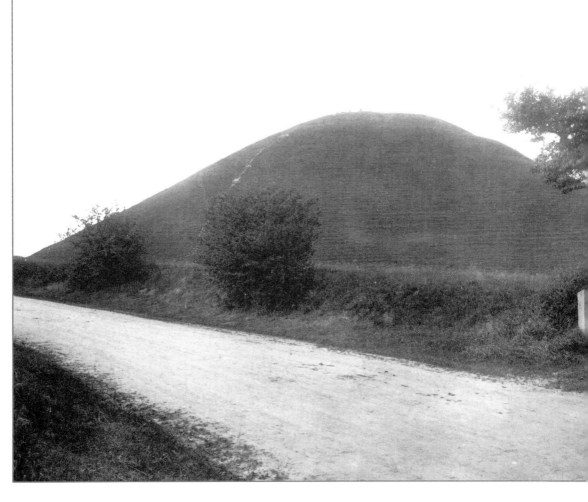

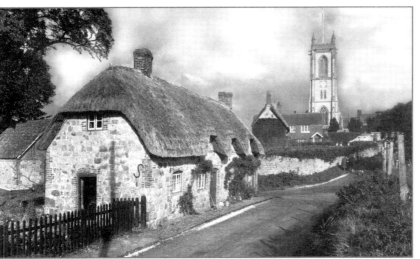

◀ **West Overton
The Village Centre c195**
W564008
This quaint old pair of
18th-century cottages are
built out of the local sarsen
stone. Beyond is the
Old Manor, dating from
the early 16th century.
It contains 17th-century
panelling which originally
came from Devon. Behind
it rises the slim tower of
St Michael's Church, a late
Victorian construction.

◀ Avebury, Silbury Hill 1902

48647

An enigma to this day, the purpose of Silbury Hill remains a mystery. Local legend had it that in ages past King Sil was buried here on horseback. William Stukely, the early 18th-century antiquarian, suggested that the prehistoric King Kunedha who lived in Marlborough founded Avebury and was interred in the mound at Silbury.

▼ Lockeridge, The Dene c1955

L189004

The Dene, now a conservation area, is a fascinating place where sarsens appear to grow out of the ground. In fact these huge blocks slithered down the sides of the hills after the last ice age, and have sometimes been mistaken for resting sheep. It is this place and Clatford Bottom nearby that were the likely sources of stone for the Avebury Circle.

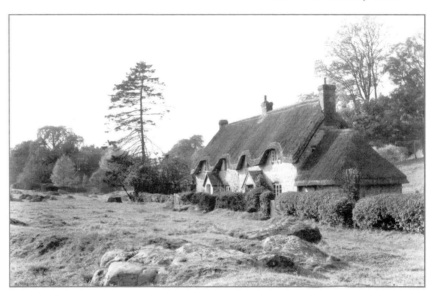

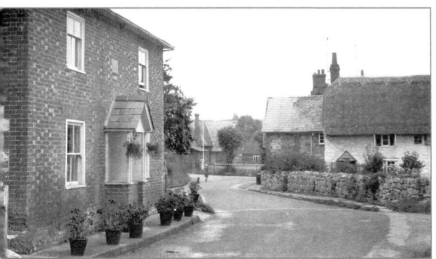

◀ Lockeridge The Village c1955

L189304

This is the centre of the village; we are looking north to West Overton County Primary School with its toothed ridge line and bell tower just visible over it. To the right is the thatched Myrtle Cottage. This 17th-century listed sarsen and brick dwelling shows the fast-disappearing type of long straw thatch, which was sewed all along the edges like a garment.

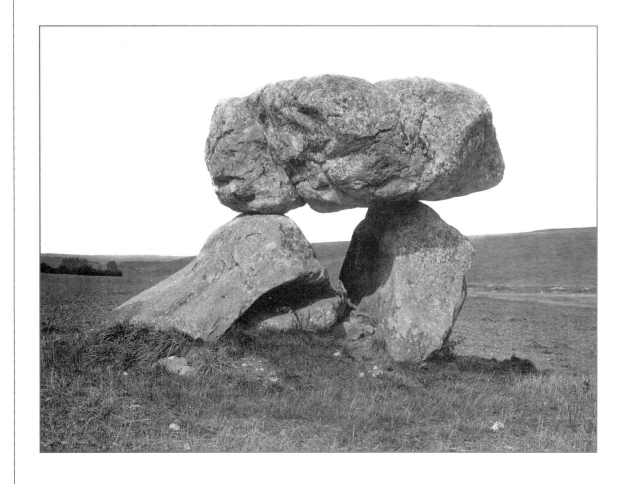

Fyfield
The Devil's Den 1901 47674
This megalithic structure consisting of two massive sarsen uprights
and a capstone was once a burial chamber enclosed by a long
mound of earth. It is said that an attempt to tear it down in the
19th century was stopped by 'enchantment' when the horses
harness apparently fell to pieces.

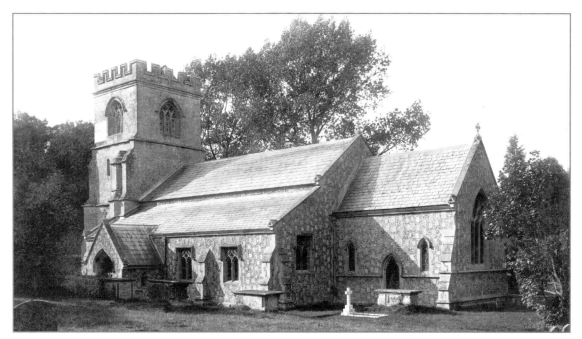

Preshute, St George's Church 1901 47668
Preshute is now a part of Marlborough, and its parish church is now encompassed by the buildings of the College. St George's once served a scattered population from Mildenhall to Fyfield, and originates in the 12th century. In 1854 it was largely rebuilt in the present flint and ashlar chequers.

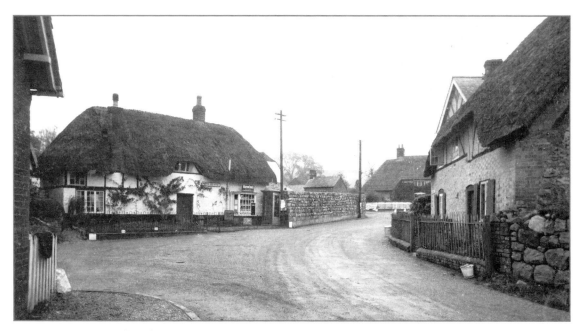

Manton, The Post Office from Bridge Street c1955 M163007
Once a village in its own right, Manton lies immediately to the west of Marlborough, and is now a part of the town. The post office, a modernised 17th-century building, is a pleasing mixture of brick, stone and timber framing under long straw thatch; so is No 73 High Street to the right of the picture, which has its origins in the 15th century or earlier.

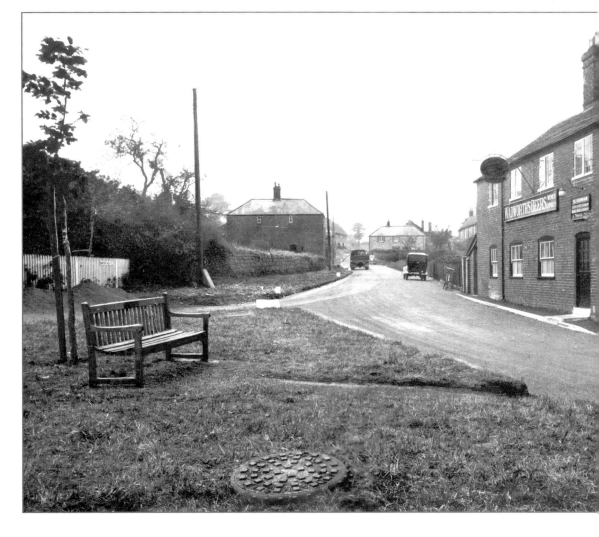

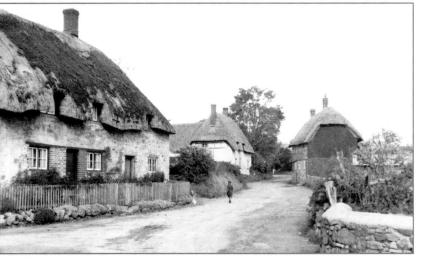

◄ **Ogbourne St Andrew The Village c1955** 05600
This small picturesque village is one of several taking its name from the stream wandering through the river valley. The scene here is much changed from today. On the left is Sunrise Cottage, formerly three 18th-century cottages. It has since lost its thatch. Along from it is the 16th-century Old Cottage, and on the right is The Thatch of c1600.

Manton
The Oddfellows Arms
and High Street c1955
M163008

At the east end of the High
Street is the Oddfellows Arms,
an early 19th-century brick
pub. The village pound, where
stray animals were kept until
their owner claimed them,
was situated at the rear of
the pub and was removed
to make way for a car park
around the date of this
photograph.

Ogbourne St George
The Village c1955 057003

Here we see the bridge over
the river Og. Part way down
the leafy west end of the High
Street is Home Farmhouse, a
refined 18th-century building
of local sarsen and brick.
In the photograph it is still
thatched. This was a working
farm until around the date of
the photograph.

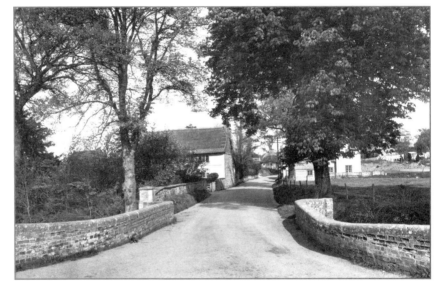

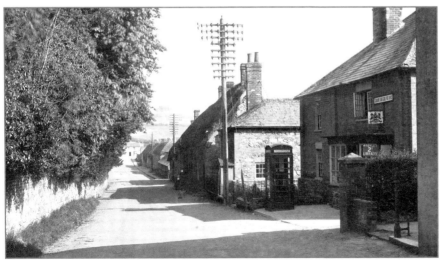

Ogbourne St George
The Post Office c1955
057005

This view looks east.
A figure pauses in the
High Street, which is
made up of 19th-century
houses sloping down to
Carlisle House at the
bottom. On the right
is the Post Office,
offering such amenities
as a telephone box
and Foyles 2D Library.
On the left is the wall
to The Park.

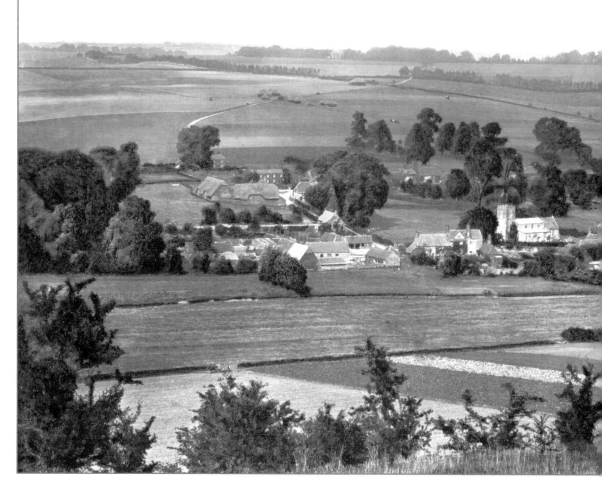

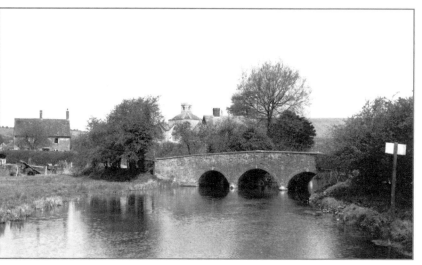

◀ **Mildenhall
Werg Bridge c1955**
M326001
The brick bridge was
built by a former rector,
Charles Francis, in the
earlier 19th century. Behind
it, its octagonal lantern
rising above the tree line, is
the School House, built in
1823 by Robert Abraham,
also for Charles Francis.
Fourteen years after this
photograph was taken, the
school closed; the building
is now a private dwelling.

◀ **Mildenhall**
The Village 1906 57191
Situated about two miles east of Marlborough, Mildenhall is a mixture of brick, flint, thatch and tiled buildings. The name is thought to derive from the Saxon 'mild as healh', meaning 'corner of land'. It is viewed here against the backdrop of the Marlborough Downs from the direction of Savernake forest.

▼ **Mildenhall**
The River Kennet c1955 M326002
The Kennet meanders through the east end of the village on its way to Stitchcombe. The building in the foreground is The Old Forge and Old Forge Cottage, built in the late 19th century. Note the person about to enter what looks like one of a pair of earth closets on the bank of the river. Behind it are newly-built council houses. The area between the bungalow and The Leaze on the right has now been built up.

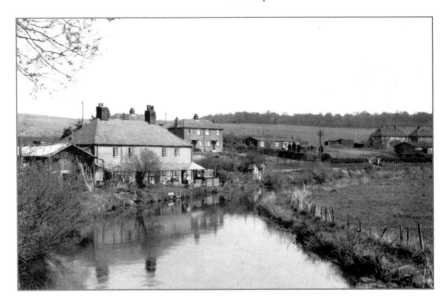

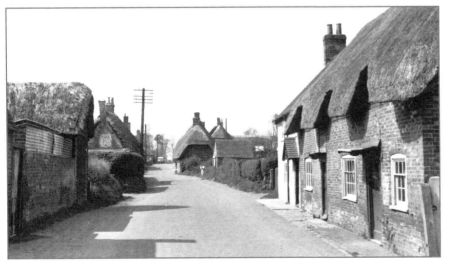

◀ **Mildenhall**
The Village c1955
M326003
We are at the east end of the main street. The three thatched cottages on the right have now been turned into two, and the nearest door is now blocked up. Here, as elsewhere, the traditional long straw thatch has been replaced with the ubiquitous wheat reed. Note the bootscraper outside the middle cottage, which has long since gone.

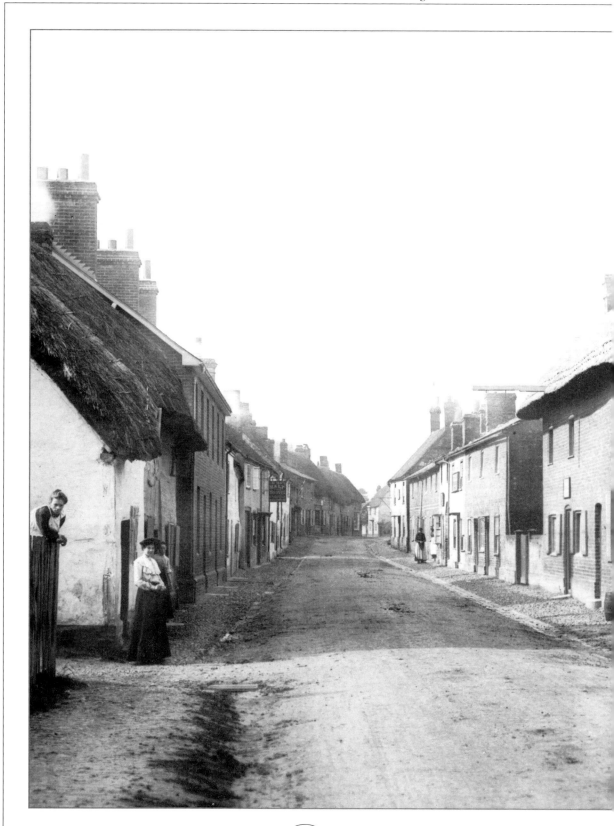

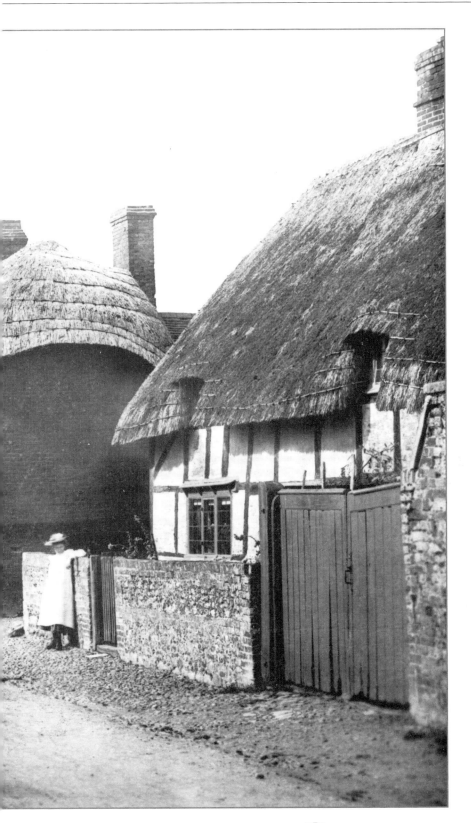

Ramsbury
High Street 1906
57194
Numerous villagers
peer out of their doors
and over the fences
on this otherwise quiet
street. Today the scene
is different; the
thatched cottage with
the white wall on the
left has been replaced
by the fire station.
Opposite, the thatched
brick building was
completely remodelled
before 1920 and called
The White House.
Before the end of the
20th century it was
remodelled again, and
is now the Burdett
Arms. It stands at the
narrow entrance to
Burdett Street,
previously known as
White House Lane.

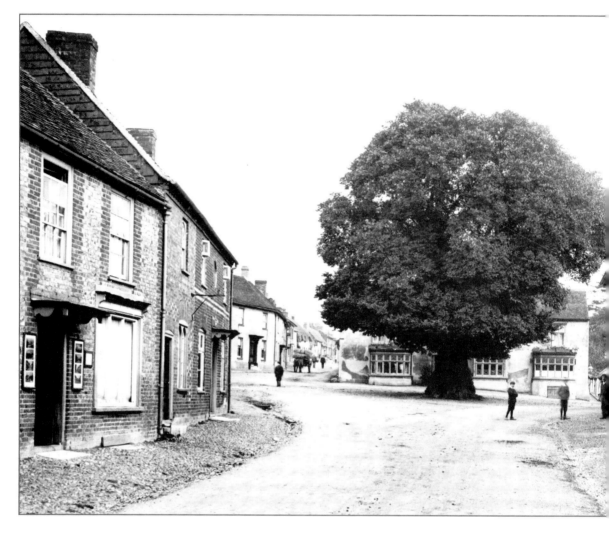

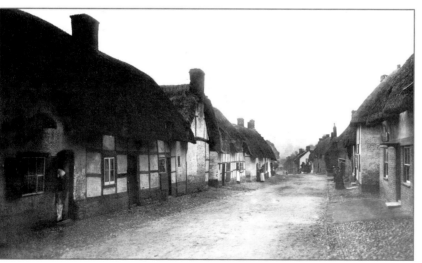

◄ **Ramsbury**
Oxford Street 1906 57197
A hive of industry; in 1910
Oxford Street was home to
doctors, bakers, carpenters,
a pork butcher, shoemakers
and repairers and the
Primitive Methodist Chapel.
Many of the thatched
buildings seen here survive
to this day, though modern
paving replaces the cobbles.

◀ **Ramsbury**
High Street 1906 57195
The great elm in the Square
presides over village activity.
On the right is One and All,
a wine and spirit merchants,
and next to it is Hill Brothers,
grocers and spirit distillers,
established in 1794.
Behind the Elm is the
Bell Inn, once a coaching inn
on the London to Bath road.
The elm, thought to have
been about 300 years old
when it died, has now been
replaced with a young oak.

▼ **Ramsbury**
Burdett Street 1906 57200
We are looking towards
Back Lane. This is a street
mainly of 16th- or 17th-
century timber-framed
cottages. In the garden of
No 2, on the bottom left of
the picture, a plague pit was
found with the remains of
five skeletons, a legacy of
the Black Death in 1348-9.
The lady wearing a flat cap
looks like she means
business!

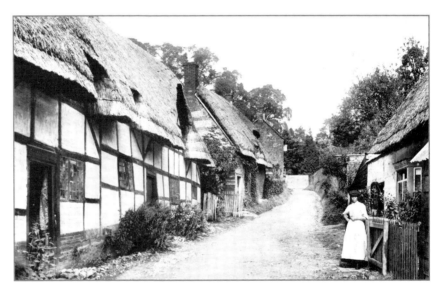

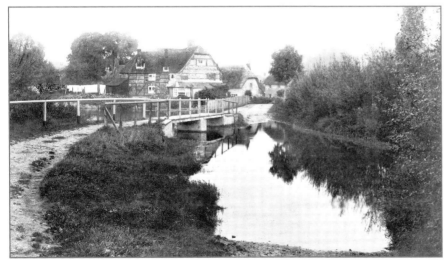

◀ **Ramsbury**
Moon's Mill 1907
57202
Thought to have
been built in the late
17th century, this fine
old mill house, once one
of ten in the Ramsbury
area, was turned into a
dwelling as late as the
1960s. Now called
Moon's Mill, it was
previously known
as Upper Mill in the
18th century, Gibbs'
Mill, and Edwards Mill in
the mid 19th century.

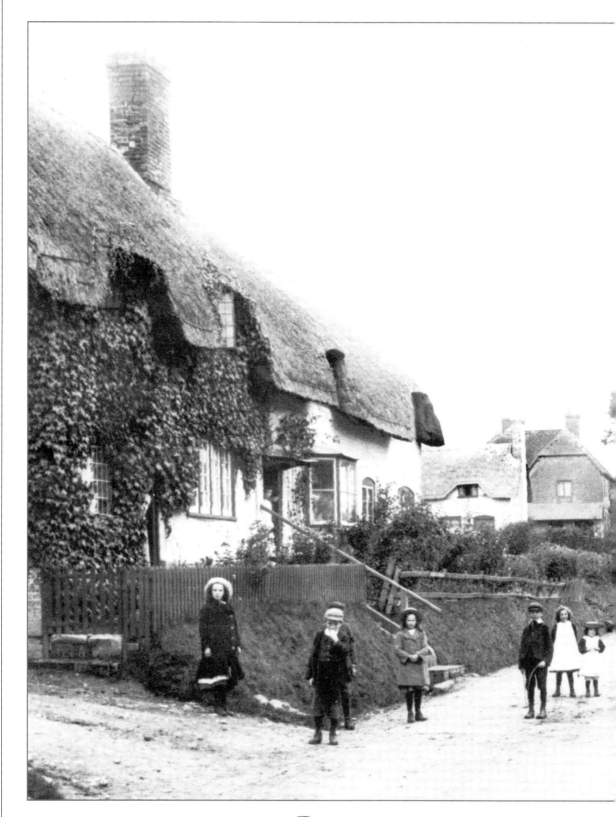

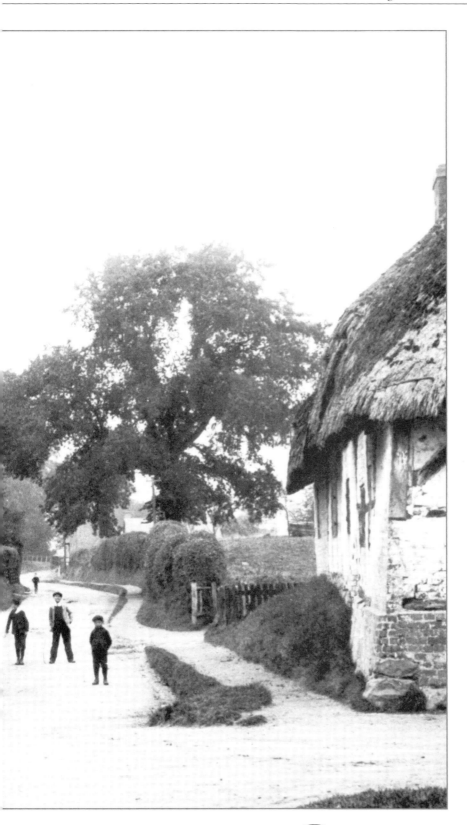

Burbage
The Village 1907
57208
This peaceful scene of village children playing in the High Street with hoops could only be possible before the advent of the motor car. To the left in the photograph is Christmas Cottage, believed to date from the 17th century.

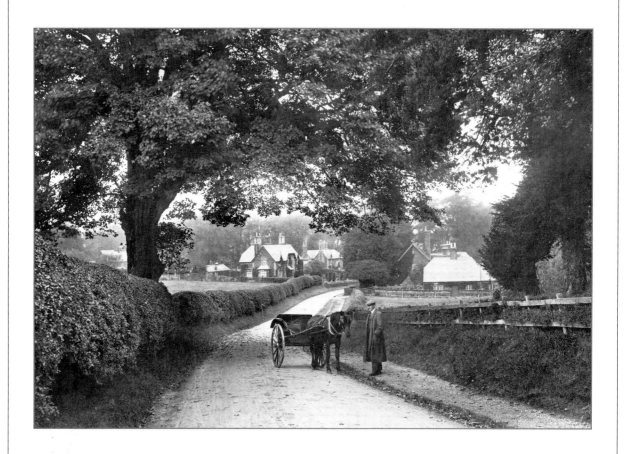

Durley
The Village 1907 57218
A part of Burbage, Durley is a scattered hamlet on the edge of
Savernake Forest. The impressive beech avenues were planted in
the 18th century, providing welcome shade for the patient horse
in this picture. The buildings visible in the background were altered
or built in the mid to late 19th century for the Ailesbury Estate in a
picturesque Gothic style.

Durley, The Post Office c1955 D113002
This building, like others in Durley, is built in the distinctive Ailesbury Estate style of red brick with yellow diamond patterns. The chunky chimneys and decorated gables add to the rustic charm. An ancient beech looms over it.

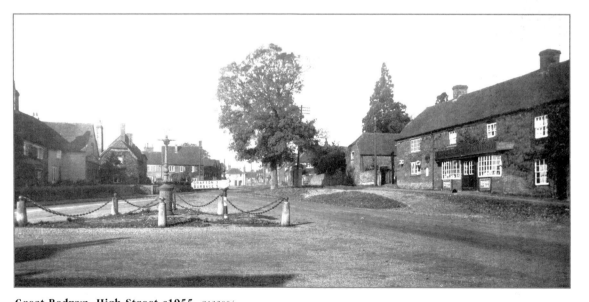

Great Bedwyn, High Street c1955 G132004
In the foreground is a chained area enclosing the Jubilee Memorial lamp standard. It was erected on the site of the old market hall, which was demolished in c1860. Behind the telegraph pole in the middle of the picture is a listed cast iron telephone kiosk of a type designed in 1935 by Sir Giles Gilbert Scott.

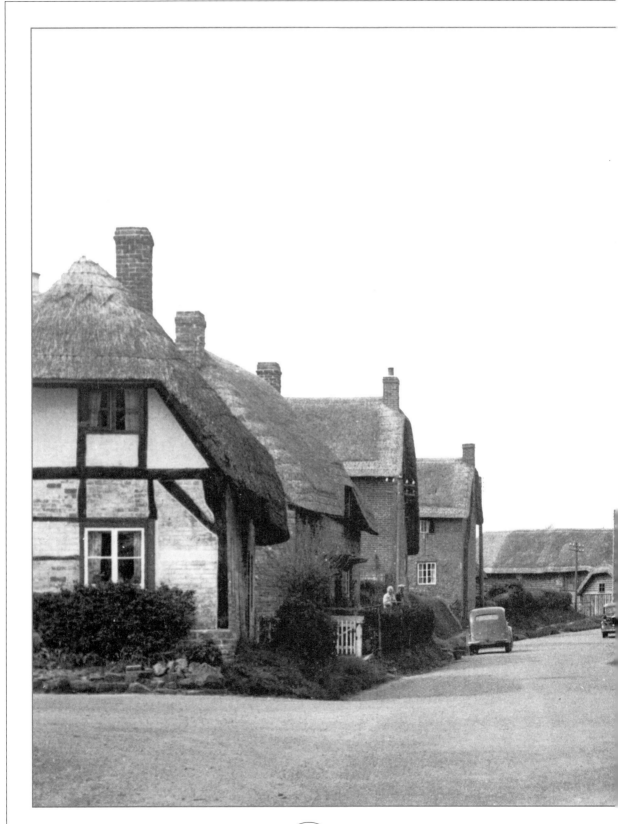

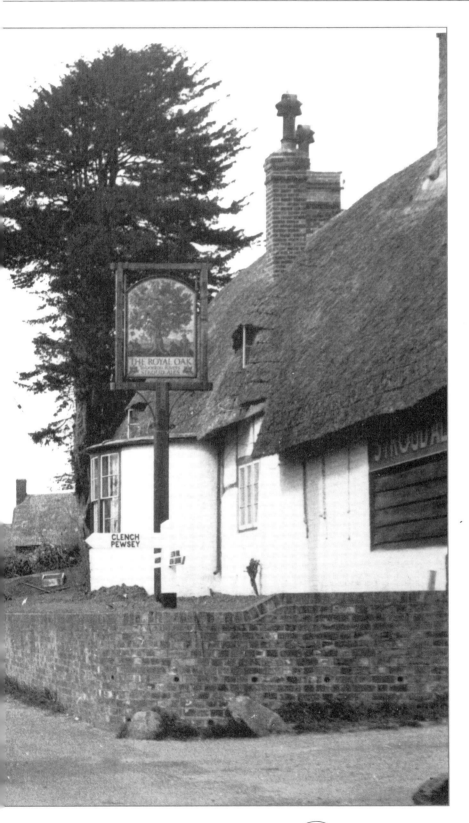

**Wootton Rivers
The Village c1950**
W269002
The name of this village means 'farm by the woods'. On the right is the Royal Oak, a 17th-century listed pub with an unusual round-ended bar; perhaps it was once a horse engine, given that the part to the right was a barn. On the left are houses dating from the 17th century (the timber-framed one) to the 18th and 19th centuries (the buildings beyond). The thatched barn in the distance has been replaced by modern housing.

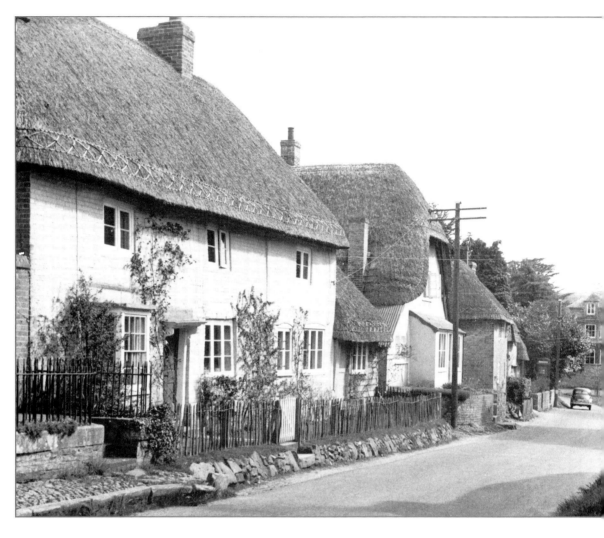

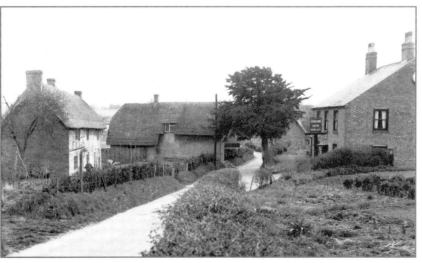

◀ **Milton Lilbourne
New Mill c1955** M165042
This settlement was built up
around the wharf on the
Kennet and Avon Canal
in the late 18th century.
The local pub, the New Inn,
moved out of one of the
cottages to a new house,
which we see on the right,
in c1850. It was renamed
the Liddiard Arms in the late
1930s and remained a pub
until around 1980, when it
closed.

Milton Lilbourne
The Village c1955 M165001
We are looking south to King Hall. This peaceful village to the south of Marlborough is one long street retaining many old cottages. To the left is The Old Bakery, an 18th-century brick house, which then had a newly thatched roof. The grand house at the top is King Hall, dating from the early 19th century. It is said to have been built on the site of a house belonging to the King's tax gatherer, hence its present name. Note the cobbled paving on the extreme left.

Savernake
The Forest, the Lodge
Gates 1906 57187
This is a typical lodge house of the Ailesbury Estate variety; it bears Gothic features such as the ornate barge-boards and detailing to the eaves. This lodge has fish-scale tiles that were popular in the later 19th century. Labourers working nearby have obviously been drafted in to add a rustic charm to the picture.

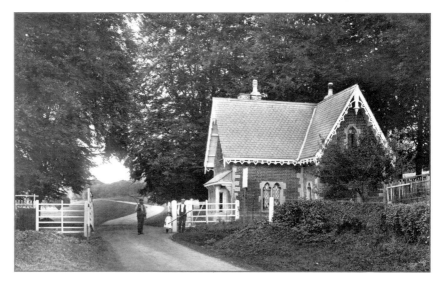

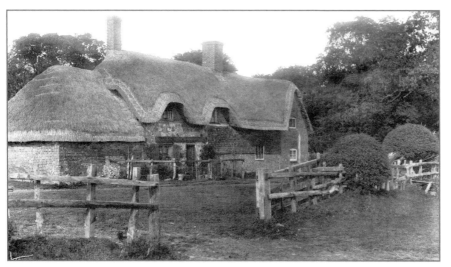

Savernake
Brown's Farm 1908
60949
This fine old 17th-century farmhouse, built in a mixture of materials, stone, brick, tile-hanging and long straw thatch, is typical of the area around Marlborough. It was known as Brown's by 1718. By the middle of the 20th century it was being used as an outhouse, and it was demolished in 1961–2 to make way for more modern farm buildings.

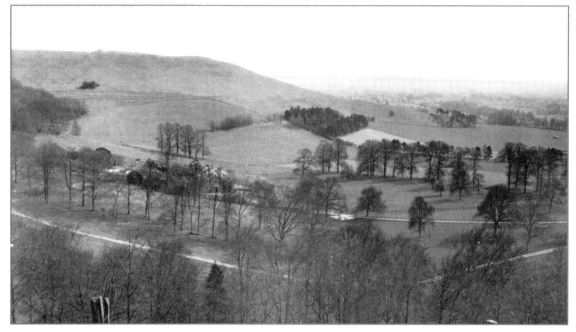

Oare, From Martinsell Hill c1955 055002
The compact hamlet of Oare lies at the foot of the Marlborough Downs. It is surrounded by numerous earthworks, including a hill-fort on the summit of Huish Hill opposite. The name Oare is derived from the Old English 'ora', meaning 'edge of a hill'.

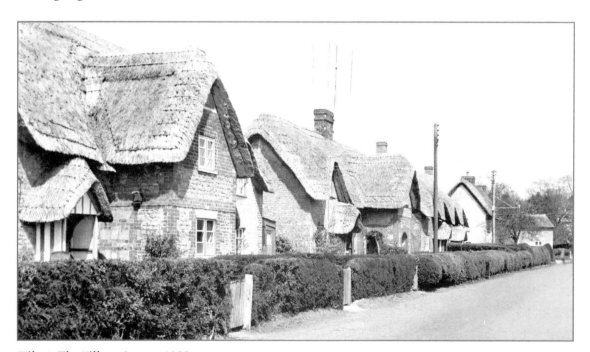

Wilcot, The Village Green c1955 W266001
These cottages are just a few of around forty built around a triangular village green for the Wroughton Estate; some are known to have housed the workers at Wilcot Manor House. They were built between the later 18th century and the late 19th century. The oldest ones have now been replaced with council housing.

Index

Frith Book Co Titles

www.francisfrith.co.uk

The Frith Book Company publishes over 100 new titles each year. A selection of those currently available are listed below. For latest catalogue please contact Frith Book Co.

Town Books 96 pages, approx 100 photos. County and Themed Books 128 pages, approx 150 photos (unless specified). All titles hardback laminated case and jacket except those indicated pb (paperback)

Amersham, Chesham & Rickmansworth (pb)			Derby (pb)	1-85937-367-4	£9.99
	1-85937-340-2	£9.99	Derbyshire (pb)	1-85937-196-5	£9.99
Ancient Monuments & Stone Circles	1-85937-143-4	£17.99	Devon (pb)	1-85937-297-x	£9.99
Aylesbury (pb)	1-85937-227-9	£9.99	Dorset (pb)	1-85937-269-4	£9.99
Bakewell	1-85937-113-2	£12.99	Dorset Churches	1-85937-172-8	£17.99
Barnstaple (pb)	1-85937-300-3	£9.99	Dorset Coast (pb)	1-85937-299-6	£9.99
Bath (pb)	1-85937419-0	£9.99	Dorset Living Memories	1-85937-210-4	£14.99
Bedford (pb)	1-85937-205-8	£9.99	Down the Severn	1-85937-118-3	£14.99
Berkshire (pb)	1-85937-191-4	£9.99	Down the Thames (pb)	1-85937-278-3	£9.99
Berkshire Churches	1-85937-170-1	£17.99	Down the Trent	1-85937-311-9	£14.99
Blackpool (pb)	1-85937-382-8	£9.99	Dublin (pb)	1-85937-231-7	£9.99
Bognor Regis (pb)	1-85937-431-x	£9.99	East Anglia (pb)	1-85937-265-1	£9.99
Bournemouth	1-85937-067-5	£12.99	East London	1-85937-080-2	£14.99
Bradford (pb)	1-85937-204-x	£9.99	East Sussex	1-85937-130-2	£14.99
Brighton & Hove(pb)	1-85937-192-2	£8.99	Eastbourne	1-85937-061-6	£12.99
Bristol (pb)	1-85937-264-3	£9.99	Edinburgh (pb)	1-85937-193-0	£8.99
British Life A Century Ago (pb)	1-85937-213-9	£9.99	England in the 1880s	1-85937-331-3	£17.99
Buckinghamshire (pb)	1-85937-200-7	£9.99	English Castles (pb)	1-85937-434-4	£9.99
Camberley (pb)	1-85937-222-8	£9.99	English Country Houses	1-85937-161-2	£17.99
Cambridge (pb)	1-85937-422-0	£9.99	Essex (pb)	1-85937-270-8	£9.99
Cambridgeshire (pb)	1-85937-420-4	£9.99	Exeter	1-85937-126-4	£12.99
Canals & Waterways (pb)	1-85937-291-0	£9.99	Exmoor	1-85937-132-9	£14.99
Canterbury Cathedral (pb)	1-85937-179-5	£9.99	Falmouth	1-85937-066-7	£12.99
Cardiff (pb)	1-85937-093-4	£9.99	Folkestone (pb)	1-85937-124-8	£9.99
Carmarthenshire	1-85937-216-3	£14.99	Glasgow (pb)	1-85937-190-6	£9.99
Chelmsford (pb)	1-85937-310-0	£9.99	Gloucestershire	1-85937-102-7	£14.99
Cheltenham (pb)	1-85937-095-0	£9.99	Great Yarmouth (pb)	1-85937-426-3	£9.99
Cheshire (pb)	1-85937-271-6	£9.99	Greater Manchester (pb)	1-85937-266-x	£9.99
Chester	1-85937-090-x	£12.99	Guildford (pb)	1-85937-410-7	£9.99
Chesterfield	1-85937-378-x	£9.99	Hampshire (pb)	1-85937-279-1	£9.99
Chichester (pb)	1-85937-228-7	£9.99	Hampshire Churches (pb)	1-85937-207-4	£9.99
Colchester (pb)	1-85937-188-4	£8.99	Harrogate	1-85937-423-9	£9.99
Cornish Coast	1-85937-163-9	£14.99	Hastings & Bexhill (pb)	1-85937-131-0	£9.99
Cornwall (pb)	1-85937-229-5	£9.99	Heart of Lancashire (pb)	1-85937-197-3	£9.99
Cornwall Living Memories	1-85937-248-1	£14.99	Helston (pb)	1-85937-214-7	£9.99
Cotswolds (pb)	1-85937-230-9	£9.99	Hereford (pb)	1-85937-175-2	£9.99
Cotswolds Living Memories	1-85937-255-4	£14.99	Herefordshire	1-85937-174-4	£14.99
County Durham	1-85937-123-x	£14.99	Hertfordshire (pb)	1-85937-247-3	£9.99
Croydon Living Memories	1-85937-162-0	£9.99	Horsham (pb)	1-85937-432-8	£9.99
Cumbria	1-85937-101-9	£14.99	Humberside	1-85937-215-5	£14.99
Dartmoor	1-85937-145-0	£14.99	Hythe, Romney Marsh & Ashford	1-85937-256-2	£9.99

Available from your local bookshop or from the publisher

Frith Book Co Titles (continued)

Ipswich (pb)	1-85937-424-7	£9.99	St Ives (pb)	1-85937415-8	£9.99
Ireland (pb)	1-85937-181-7	£9.99	Scotland (pb)	1-85937-182-5	£9.99
Isle of Man (pb)	1-85937-268-6	£9.99	Scottish Castles (pb)	1-85937-323-2	£9.99
Isles of Scilly	1-85937-136-1	£14.99	Sevenoaks & Tunbridge	1-85937-057-8	£12.99
Isle of Wight (pb)	1-85937-429-8	£9.99	Sheffield, South Yorks (pb)	1-85937-267-8	£9.99
Isle of Wight Living Memories	1-85937-304-6	£14.99	Shrewsbury (pb)	1-85937-325-9	£9.99
Kent (pb)	1-85937-189-2	£9.99	Shropshire (pb)	1-85937-326-7	£9.99
Kent Living Memories	1-85937-125-6	£14.99	Somerset	1-85937-153-1	£14.99
Lake District (pb)	1-85937-275-9	£9.99	South Devon Coast	1-85937-107-8	£14.99
Lancaster, Morecambe & Heysham (pb)	1-85937-233-3	£9.99	South Devon Living Memories	1-85937-168-x	£14.99
Leeds (pb)	1-85937-202-3	£9.99	South Hams	1-85937-220-1	£14.99
Leicester	1-85937-073-x	£12.99	Southampton (pb)	1-85937-427-1	£9.99
Leicestershire (pb)	1-85937-185-x	£9.99	Southport (pb)	1-85937-425-5	£9.99
Lincolnshire (pb)	1-85937-433-6	£9.99	Staffordshire	1-85937-047-0	£12.99
Liverpool & Merseyside (pb)	1-85937-234-1	£9.99	Stratford upon Avon	1-85937-098-5	£12.99
London (pb)	1-85937-183-3	£9.99	Suffolk (pb)	1-85937-221-x	£9.99
Ludlow (pb)	1-85937-176-0	£9.99	Suffolk Coast	1-85937-259-7	£14.99
Luton (pb)	1-85937-235-x	£9.99	Surrey (pb)	1-85937-240-6	£9.99
Maidstone	1-85937-056-x	£14.99	Sussex (pb)	1-85937-184-1	£9.99
Manchester (pb)	1-85937-198-1	£9.99	Swansea (pb)	1-85937-167-1	£9.99
Middlesex	1-85937-158-2	£14.99	Tees Valley & Cleveland	1-85937-211-2	£14.99
New Forest	1-85937-128-0	£14.99	Thanet (pb)	1-85937-116-7	£9.99
Newark (pb)	1-85937-366-6	£9.99	Tiverton (pb)	1-85937-178-7	£9.99
Newport, Wales (pb)	1-85937-258-9	£9.99	Torbay	1-85937-063-2	£12.99
Newquay (pb)	1-85937-421-2	£9.99	Truro	1-85937-147-7	£12.99
Norfolk (pb)	1-85937-195-7	£9.99	Victorian and Edwardian Cornwall	1-85937-252-x	£14.99
Norfolk Living Memories	1-85937-217-1	£14.99	Victorian & Edwardian Devon	1-85937-253-8	£14.99
Northamptonshire	1-85937-150-7	£14.99	Victorian & Edwardian Kent	1-85937-149-3	£14.99
Northumberland Tyne & Wear (pb)	1-85937-281-3	£9.99	Vic & Ed Maritime Album	1-85937-144-2	£17.99
North Devon Coast	1-85937-146-9	£14.99	Victorian and Edwardian Sussex	1-85937-157-4	£14.99
North Devon Living Memories	1-85937-261-9	£14.99	Victorian & Edwardian Yorkshire	1-85937-154-x	£14.99
North London	1-85937-206-6	£14.99	Victorian Seaside	1-85937-159-0	£17.99
North Wales (pb)	1-85937-298-8	£9.99	Villages of Devon (pb)	1-85937-293-7	£9.99
North Yorkshire (pb)	1-85937-236-8	£9.99	Villages of Kent (pb)	1-85937-294-5	£9.99
Norwich (pb)	1-85937 194-9	£8.99	Villages of Sussex (pb)	1-85937-295-3	£9.99
Nottingham (pb)	1-85937-324-0	£9.99	Warwickshire (pb)	1-85937-203-1	£9.99
Nottinghamshire (pb)	1-85937-187-6	£9.99	Welsh Castles (pb)	1-85937-322-4	£9.99
Oxford (pb)	1-85937-411-5	£9.99	West Midlands (pb)	1-85937-289-9	£9.99
Oxfordshire (pb)	1-85937-430-1	£9.99	West Sussex	1-85937-148-5	£14.99
Peak District (pb)	1-85937-280-5	£9.99	West Yorkshire (pb)	1-85937-201-5	£9.99
Penzance	1-85937-069-1	£12.99	Weymouth (pb)	1-85937-209-0	£9.99
Peterborough (pb)	1-85937-219-8	£9.99	Wiltshire (pb)	1-85937-277-5	£9.99
Piers	1-85937-237-6	£17.99	Wiltshire Churches (pb)	1-85937-171-x	£9.99
Plymouth	1-85937-119-1	£12.99	Wiltshire Living Memories	1-85937-245-7	£14.99
Poole & Sandbanks (pb)	1-85937-251-1	£9.99	Winchester (pb)	1-85937-428-x	£9.99
Preston (pb)	1-85937-212-0	£9.99	Windmills & Watermills	1-85937-242-2	£17.99
Reading (pb)	1-85937-238-4	£9.99	Worcester (pb)	1-85937-165-5	£9.99
Romford (pb)	1-85937-319-4	£9.99	Worcestershire	1-85937-152-3	£14.99
Salisbury (pb)	1-85937-239-2	£9.99	York (pb)	1-85937-199-x	£9.99
Scarborough (pb)	1-85937-379-8	£9.99	Yorkshire (pb)	1-85937-186-8	£9.99
St Albans (pb)	1-85937-341-0	£9.99	Yorkshire Living Memories	1-85937-166-3	£14.99

See Frith books on the internet www.francisfrith.co.uk

FRITH PRODUCTS & SERVICES

Francis Frith would doubtless be pleased to know that the pioneering publishing venture he started in 1860 still continues today. A hundred and forty years later, The Francis Frith Collection continues in the same innovative tradition and is now one of the foremost publishers of vintage photographs in the world. Some of the current activities include:

Interior Decoration

Today Frith's photographs can be seen framed and as giant wall murals in thousands of pubs, restaurants, hotels, banks, retail stores and other public buildings throughout the country. In every case they enhance the unique local atmosphere of the places they depict and provide reminders of gentler days in an increasingly busy and frenetic world.

Product Promotions

Frith products are used by many major companies to promote the sales of their own products or to reinforce their own history and heritage. Frith promotions have been used by Hovis bread, Courage beers, Scots Porage Oats, Colman's mustard, Cadbury's foods, Mellow Birds coffee, Dunhill pipe tobacco, Guinness, and Bulmer's Cider.

Genealogy and Family History

As the interest in family history and roots grows world-wide, more and more people are turning to Frith's photographs of Great Britain for images of the towns, villages and streets where their ancestors lived; and, of course, photographs of the churches and chapels where their ancestors were christened, married and buried are an essential part of every genealogy tree and family album.

Frith Products

All Frith photographs are available Framed or just as Mounted Prints and Posters (size 23 x 16 inches). These may be ordered from the address below. From time to time other products - Address Books, Calendars, Table Mats, etc - are available.

The Internet

Already twenty thousand Frith photographs can be viewed and purchased on the internet through the Frith websites and a myriad of partner sites.

For more detailed information on Frith companies and products, look at these sites:

www.francisfrith.co.uk
www.francisfrith.com
(for North American visitors)

See the complete list of Frith Books at:

www.francisfrith.co.uk

This web site is regularly updated with the latest list of publications from the Frith Book Company. If you wish to buy books relating to another part of the country that your local bookshop does not stock, you may purchase on-line.

For further information, trade, or author enquiries please contact us at the address below:
The Francis Frith Collection, Frith's Barn, Teffont, Salisbury, Wiltshire, England SP3 5QP.
Tel: +44 (0)1722 716 376 Fax: +44 (0)1722 716 881 Email: sales@francisfrith.co.uk

See Frith books on the internet www.francisfrith.co.uk

TO RECEIVE YOUR FREE MOUNTED PRINT

Mounted Print
Overall size 14 x 11 inches

Cut out this Voucher and return it with your remittance for £1.95 to cover postage and handling, to UK addresses. For overseas addresses please include £4.00 post and handling. Choose any photograph included in this book. Your SEPIA print will be A4 in size, and mounted in a cream mount with burgundy rule line, overall size 14 x 11 inches.

Order additional Mounted Prints at HALF PRICE (only £7.49 each*)

If there are further pictures you would like to order, possibly as gifts for friends and family, purchase them at half price (no additional postage and handling required).

Have your Mounted Prints framed*

For an additional £14.95 per print you can have your chosen Mounted Print framed in an elegant polished wood and gilt moulding, overall size 16 x 13 inches (no additional postage and handling required).

*** IMPORTANT!**
These special prices are only available if ordered using the original voucher on this page (no copies permitted) and at the same time as your free Mounted Print, for delivery to the same address

Frith Collectors' Guild

From time to time we publish a magazine of news and stories about Frith photographs and further special offers of Frith products. If you would like 12 months FREE membership, please return this form.

Send completed forms to:
**The Francis Frith Collection,
Frith's Barn, Teffont, Salisbury,
Wiltshire SP3 5QP**

Voucher for **FREE** and Reduced Price Frith Prints

Picture no.	Page number	Qty	Mounted @ £7.49	Framed + £14.95	Total Cost
		1	**Free of charge***	£	£
			£7.49	£	£
			£7.49	£	£
			£7.49	£	£
			£7.49	£	£
			£7.49	£	£

Please allow 28 days for delivery	*** Post & handling**	**£1.95**
Book Title	**Total Order Cost**	**£**

Please do not photocopy this voucher. Only the original is valid, so please cut it out and return it to us.

I enclose a cheque / postal order for £
made payable to 'The Francis Frith Collection'
OR please debit my Mastercard / Visa / Switch / Amex card
(credit cards please on all overseas orders)

Number .

Issue No (Switch only) Valid from (Amex/Switch)

Expires Signature

Name Mr/Mrs/Ms .

Address .

. .

. Postcode

Daytime Tel No . Valid to 31/12/02

The Francis Frith Collectors' Guild

Please enrol me as a member for 12 months free of charge.

Name Mr/Mrs/Ms .

Address .

. .

. Postcode

Would you like to find out more about Francis Frith?

We have recently recruited some entertaining speakers who are happy to visit local groups, clubs and societies to give an illustrated talk documenting Frith's travels and photographs. If you are a member of such a group and are interested in hosting a presentation, we would love to hear from you.

Our speakers bring with them a small selection of our local town and county books, together with sample prints. They are happy to take orders. A small proportion of the order value is donated to the group who have hosted the presentation. The talks are therefore an excellent way of fundraising for small groups and societies.

Can you help us with information about any of the Frith photographs in this book?

We are gradually compiling an historical record for each of the photographs in the Frith archive. It is always fascinating to find out the names of the people shown in the pictures, as well as insights into the shops, buildings and other features depicted.

If you recognize anyone in the photographs in this book, or if you have information not already included in the author's caption, do let us know. We would love to hear from you, and will try to publish it in future books or articles.

Our production team

Frith books are produced by a small dedicated team at offices in the converted Grade II listed 18th-century barn at Teffont near Salisbury, illustrated above. Most have worked with the Frith Collection for many years. All have in common one quality: they have a passion for the Frith Collection. The team is constantly expanding, but currently includes:

Jason Buck, John Buck, Douglas Burns, Heather Crisp, Isobel Hall, Rob Hames, Hazel Heaton, Peter Horne, James Kinnear, Tina Leary, Hannah Marsh, Eliza Sackett, Terence Sackett, Sandra Sanger, Shelley Tolcher, Susanna Walker, Clive Wathen and Jenny Wathen.